WORKING LIKE A DOG

BRANDISE DANESEWICH

NICOLE ELLIS

First Edition: September 2017

ISBN-10: 0-9993859-9-2
ISBN-13: 978-0-9993859-9-9

Cover design by Sergie Loobkoff

Printed in the United States of America

We embarked on our Working Like a Dog project with the crazy notion that maybe the two of us could shine a spotlight on dogs whose responsibilities to their humans go well beyond the designation of 'pet' or 'companion'. We hoped that by inviting these dogs to express themselves in front of our cameras, we could show and share our appreciation for these brilliant, hard-working and complex canines.

Dogs – and working dogs – have had a huge impact on our own lives.

Not so many years ago, Brandise fell victim to a vicious dog attack. She was forced to take some time off of her busy international modeling career to heal her sustained injuries. Brandise focused her time off to respark her passion for photography. Photography proved cathartic in her recovery process and her injuries soon healed. Her first job back after the attack she was cast on the Emmy nominated TV series Project Runway and spinoff show Models of the Runway.

Brandise's success in photography and video rivals her success as an international model. She has shot album artwork for Jackson Browne, worked for Rolling Stone and toured with Crosby Stills and Nash working on documentary video projects. Her undeniable passion for music, animals, life on the road and photography has landed her two separate features on the social media platform Instagram as one of their suggested users.

During this time, Nicole was pursuing her dream of working with animals. She studied animal training with top trainers and learned to work with everything from bears and tigers to dogs and cats. Somewhere along the way, she decided that her mission as a trainer was actually to train other humans to strengthen their bonds with their pets through training and understanding. Happier owners means happier pets, and then hopefully fewer pets will end up on the streets and in city shelters – that was Nicole's thinking. Nicole's own dog, Maggie, who came from one of those shelters, became Nicole's animal training ambassador. In addition to working in commercials and movies, Maggie performed at hospitals, charity fundraisers and on TV, doing tricks and training demos.

After lots of late-night talks, far-flung emails and the logistical nightmares that come with making appointments to meet with dogs and their owners all over the US, we piled into Brandise's trusty Volvo station wagon for the Working Like a Dog road trip. We packed the car full of photographic equipment, lights, squeaky toys, balls, and tons of dog treats. Although we weren't really sure what to expect on this grand adventure, not a day went by when we weren't moved to tears by the stories we heard about these dogs and their owners. There were cancer-detection dogs, bedbug detectors, a dog who surfed for charity, dogs who warned their owners of life-threatening allergies, search-and-rescue dogs, cadaver dogs, mobility dogs, and so many more that we learned about. The one thing all these dogs and their owners had in common was how welcoming they were to two crazy girls who came to town with a camera. We can't thank them enough for their generosity in supporting our dream.

Brandise Danesewich + Nicole Ellis

Dedicated to all the hard-working K-9's and their handlers who make this world a better place.

From the bottom of our hearts, thank you for everyone that took time out of their day to share their incredible dogs and life stories with us, who believed in two girls and this crazy idea to share the message on what working dogs can do.

We've had so many people who have supported us along this journey that we are extremely grateful for but there are a few that stood by our sides to make sure that this book came out as amazing as it did. Thank you to Jane Rusconi as this entire book wouldn't be here without your continued support and friendship. Thank you Mark Tucker, Jared Tafralian, Colin Wright, Kirsten Erickson, Sergie Loobkoff, Patrick Mahaney, David Kalish, Katerina Kakoniktis, Joel Norton, Kerry Bennett, Chairman Meow Jr, and Maggie Ellis for support us, listening to our endless dog stories, answering questions at all hours of the night, and believing in our vision.

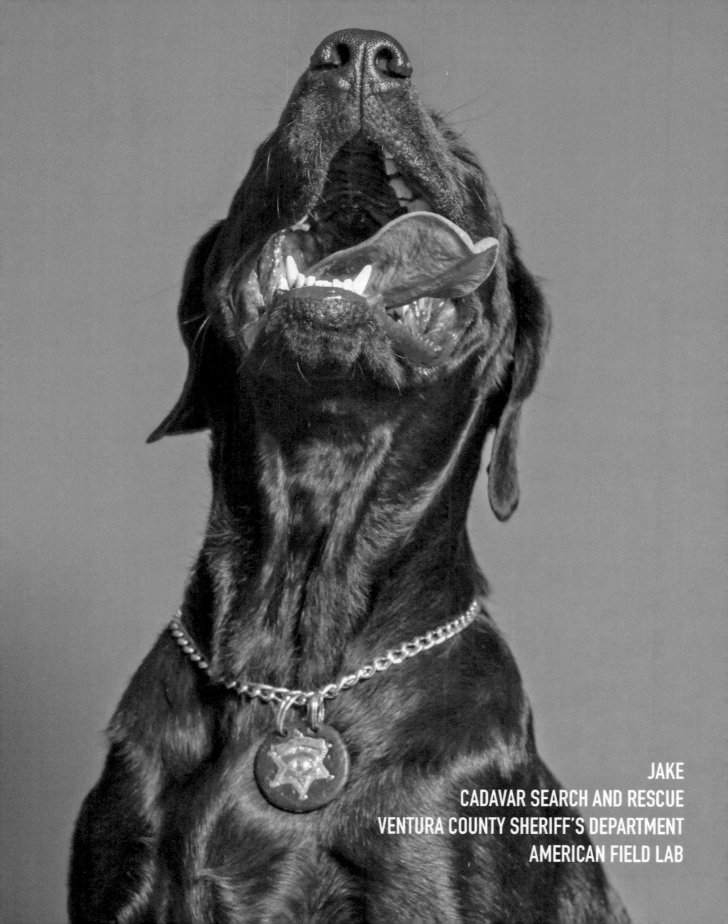

JAKE
CADAVAR SEARCH AND RESCUE
VENTURA COUNTY SHERIFF'S DEPARTMENT
AMERICAN FIELD LAB

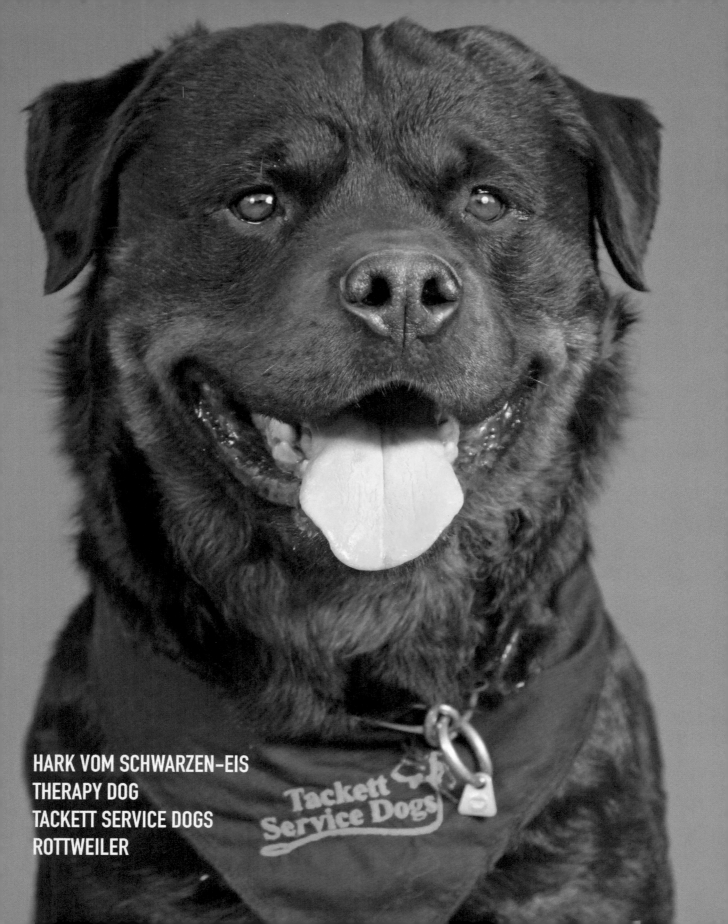

HARK VOM SCHWARZEN-EIS
THERAPY DOG
TACKETT SERVICE DOGS
ROTTWEILER

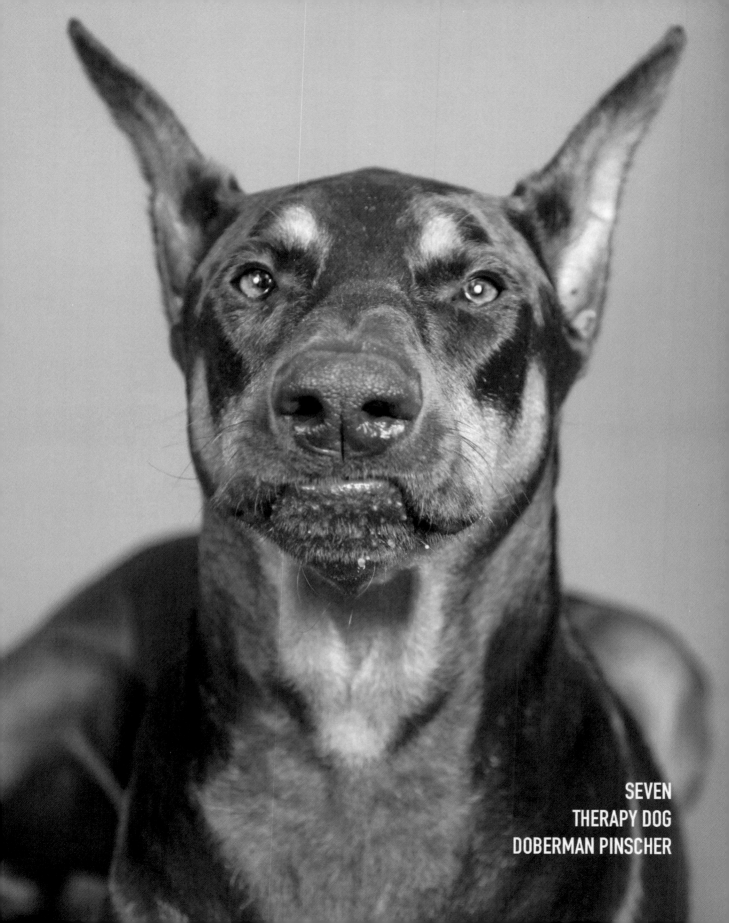

SEVEN
THERAPY DOG
DOBERMAN PINSCHER

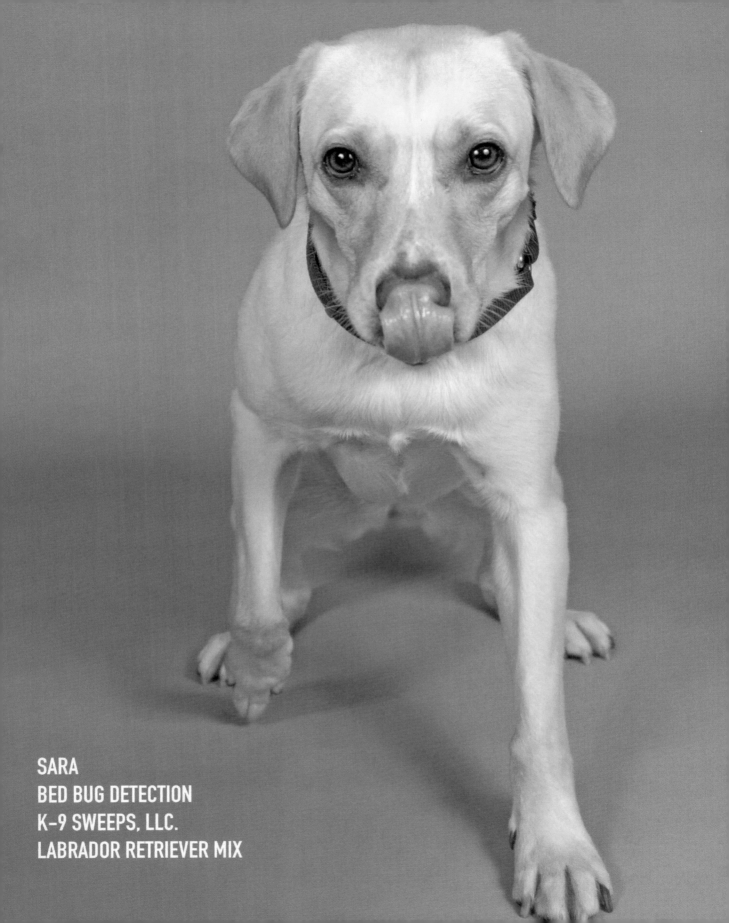

SARA
BED BUG DETECTION
K-9 SWEEPS, LLC.
LABRADOR RETRIEVER MIX

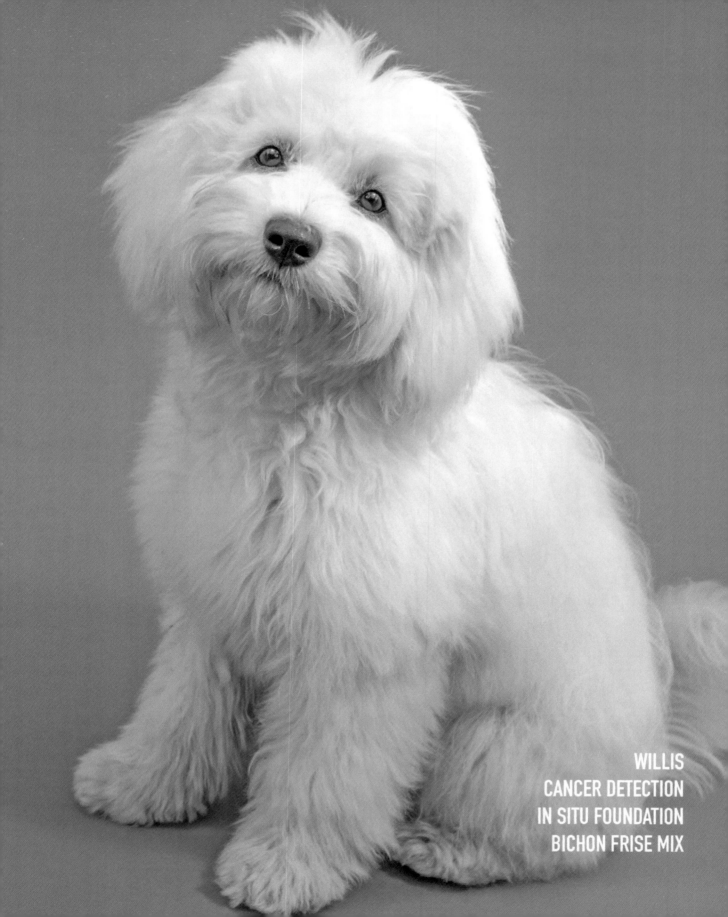

WILLIS
CANCER DETECTION
IN SITU FOUNDATION
BICHON FRISE MIX

BEN
DISASTER SEARCH AND RESCUE
NATIONAL DISASTER SEARCH DOG FOUNDATION
FIELD LABRADOR RETRIEVER

I want you to meet the love of my life; my service dog, Ozzie. He's a wonderful dog and performs about 12 different tasks to assist me with mobility. These include, but are not limited to, getting water from the fridge, picking up objects that I drop such as keys, pulling doors open for me when I'm unable to, getting clothes from the dryer, pulling me up from a seated position, bracing himself so I can push myself up on his body, and getting help if I'm in an emergency.

- Ozzie's Handler

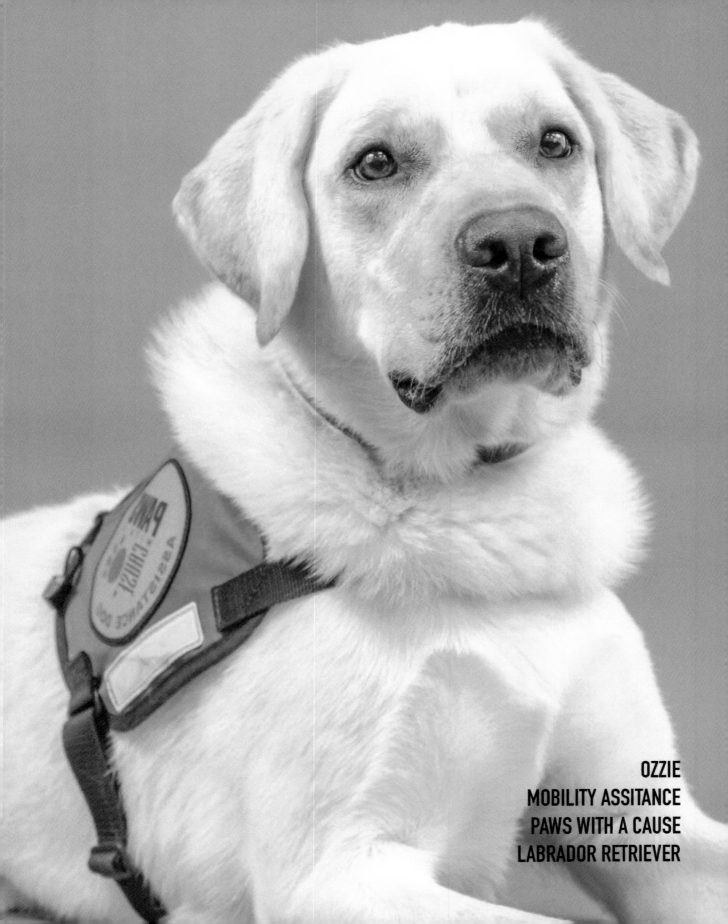

OZZIE
MOBILITY ASSITANCE
PAWS WITH A CAUSE
LABRADOR RETRIEVER

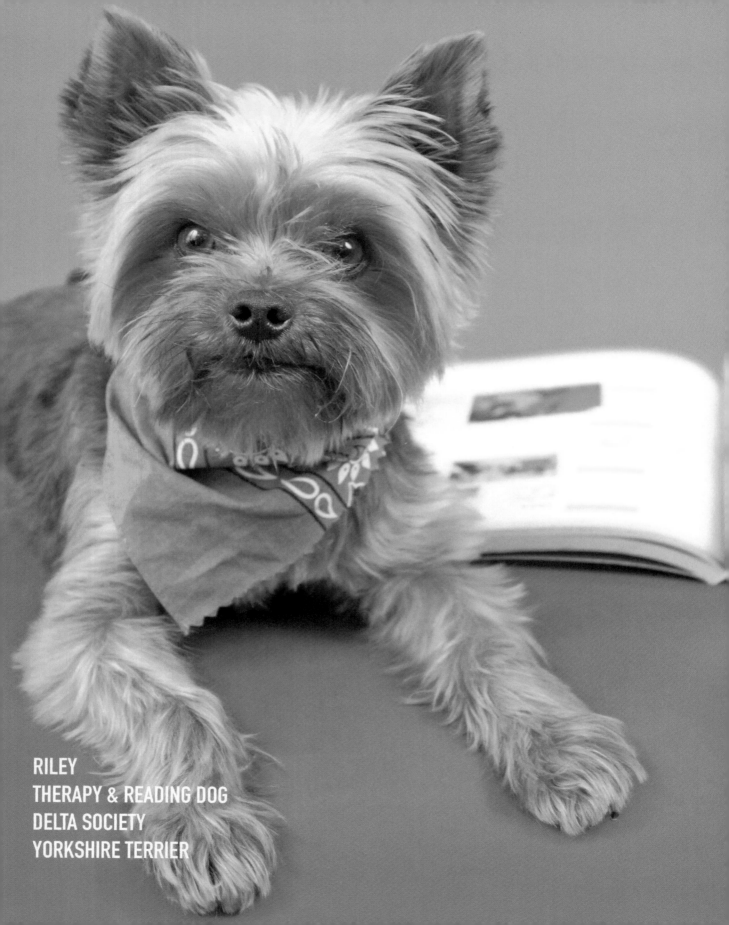

RILEY
THERAPY & READING DOG
DELTA SOCIETY
YORKSHIRE TERRIER

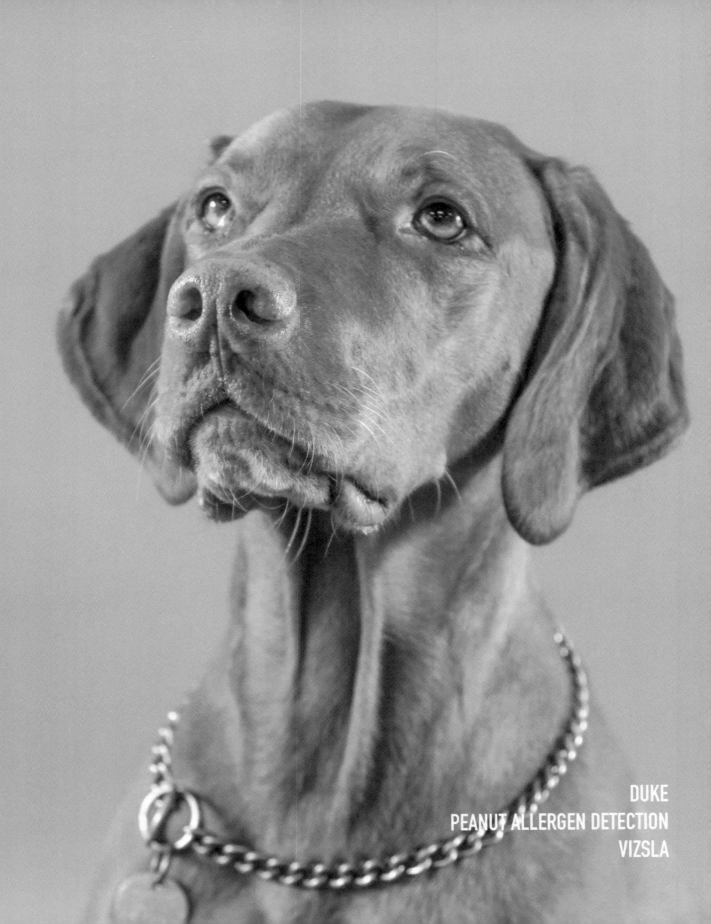

DUKE
PEANUT ALLERGEN DETECTION
VIZSLA

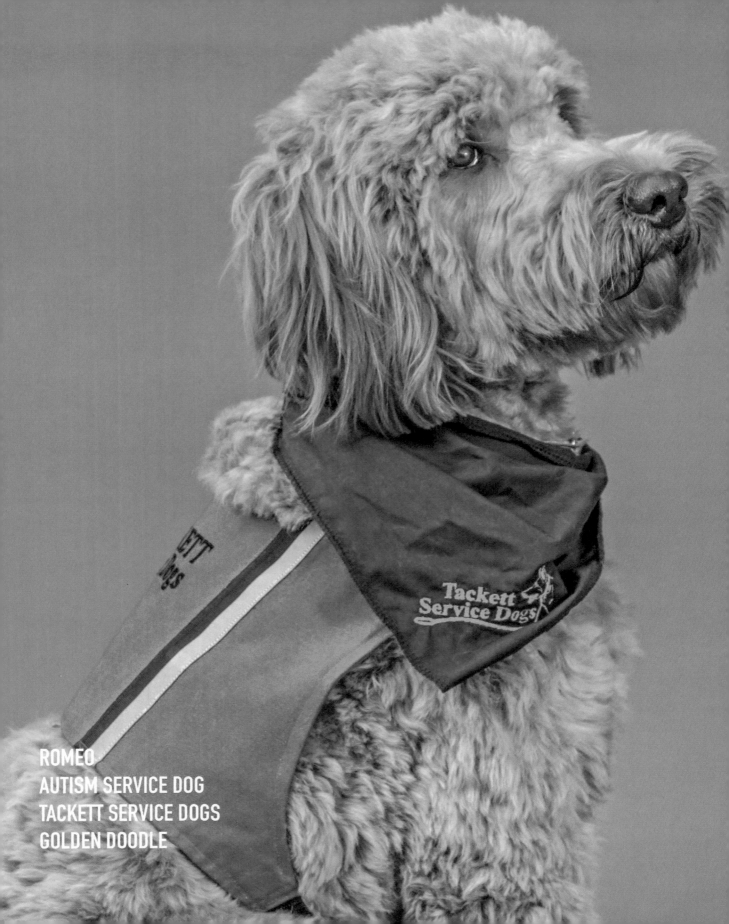

ROMEO
AUTISM SERVICE DOG
TACKETT SERVICE DOGS
GOLDEN DOODLE

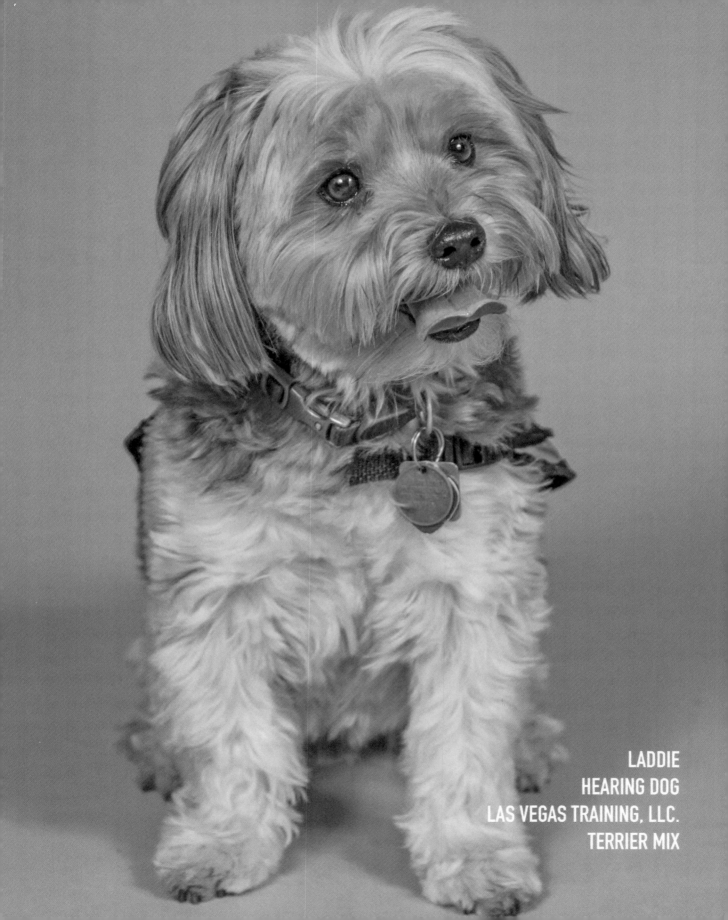

LADDIE
HEARING DOG
LAS VEGAS TRAINING, LLC.
TERRIER MIX

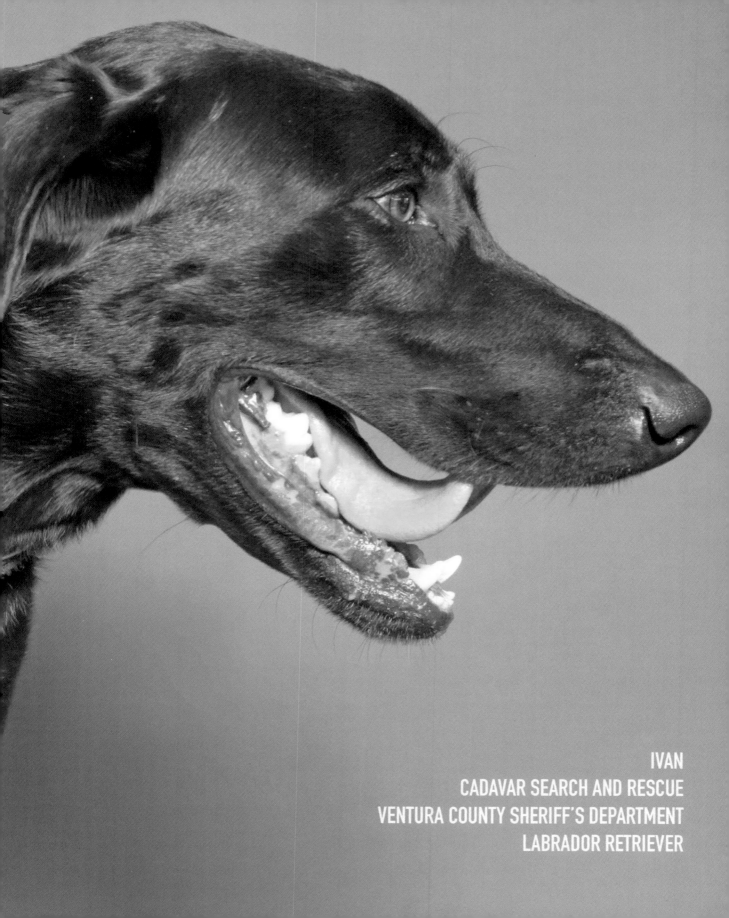

IVAN
CADAVAR SEARCH AND RESCUE
VENTURA COUNTY SHERIFF'S DEPARTMENT
LABRADOR RETRIEVER

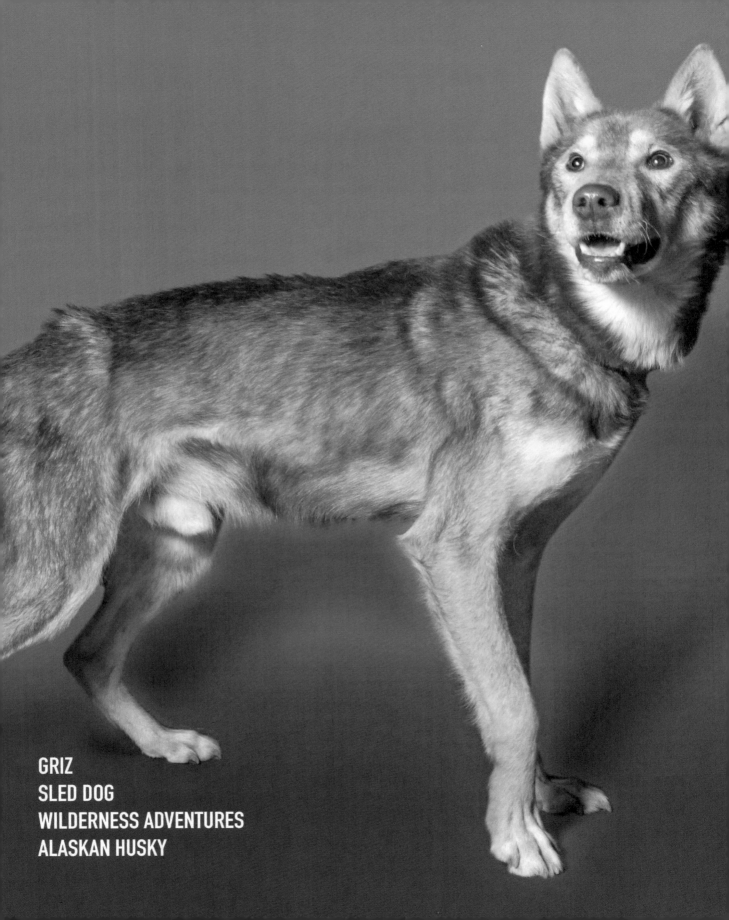

GRIZ
SLED DOG
WILDERNESS ADVENTURES
ALASKAN HUSKY

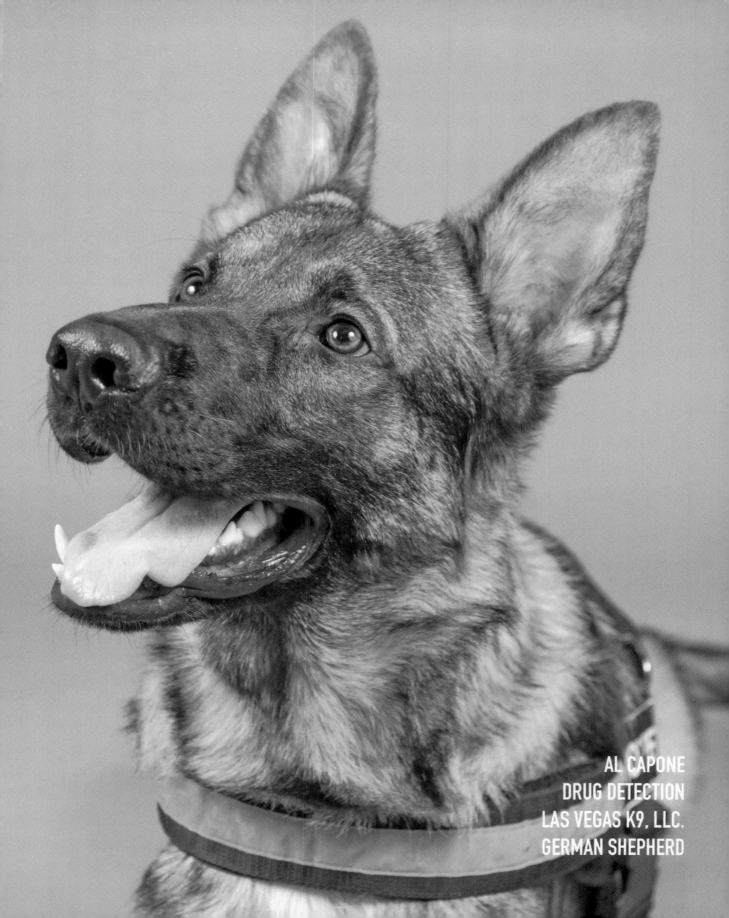

AL CAPONE
DRUG DETECTION
LAS VEGAS K9, LLC.
GERMAN SHEPHERD

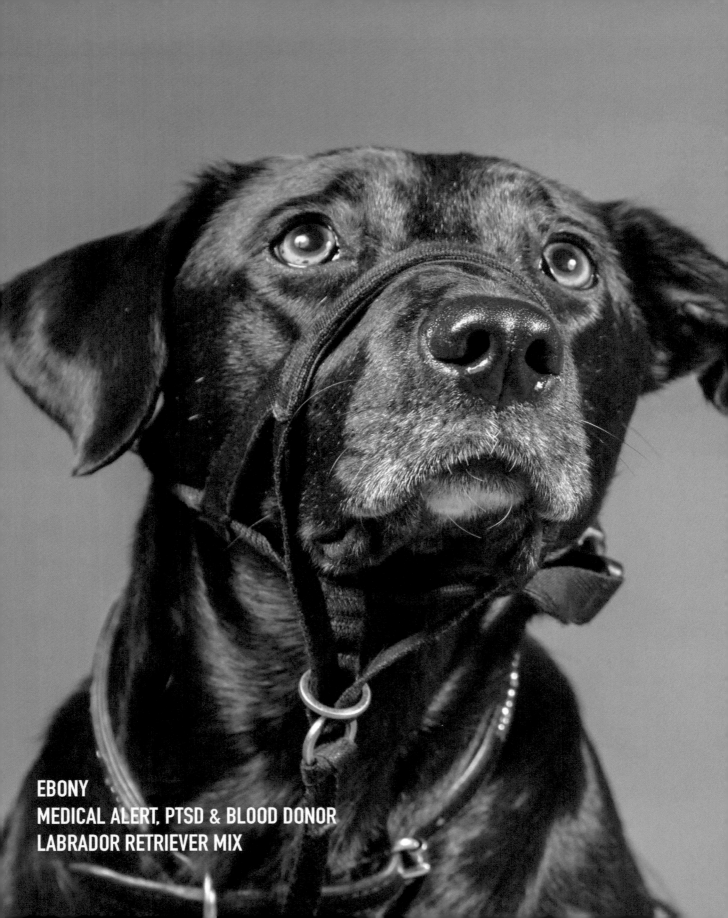

EBONY
MEDICAL ALERT, PTSD & BLOOD DONOR
LABRADOR RETRIEVER MIX

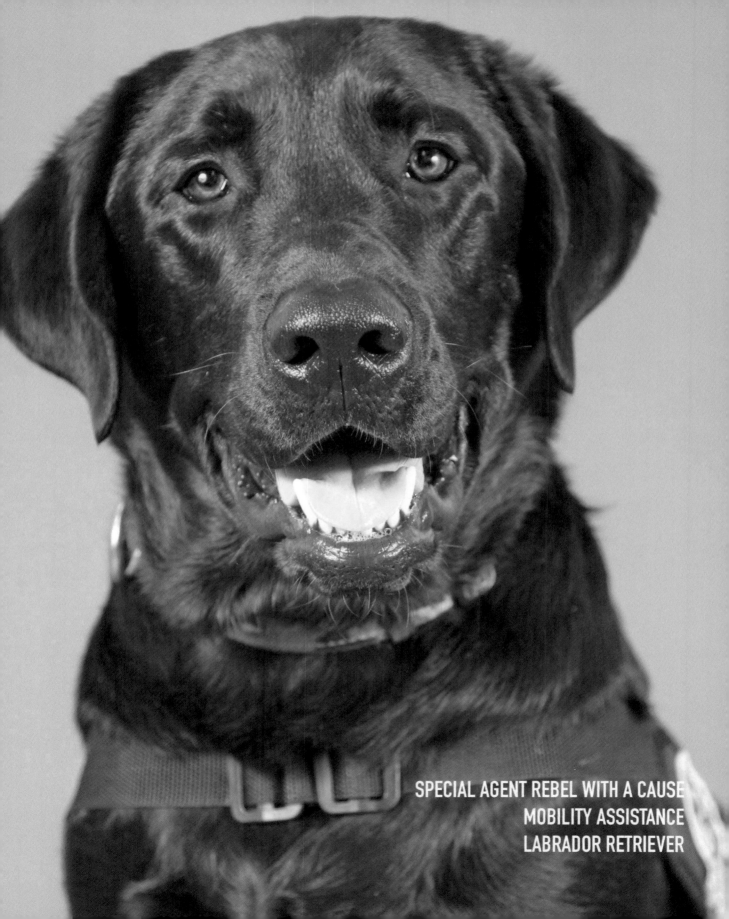

SPECIAL AGENT REBEL WITH A CAUSE
MOBILITY ASSISTANCE
LABRADOR RETRIEVER

I can't tell you how many times my service dog has saved my life. I have an allergy to the latex proteins in rubber trees, so severe that I go into anaphylactic shock. Spirit was trained to identify the scent of latex which can be found in ordinary things like medical gloves, balloons, and playground balls. Most of the time, I have no symptoms and even I can't tell I'm about to go into anaphylaxis. There's no cure for this allergy and Spirit is on alert whenever we're out of the house, wearing her medical bag with the instructions "Please don't pet me. I'm working." It's that serious. Spirit is my lifesaver.

- Spirit's Handler

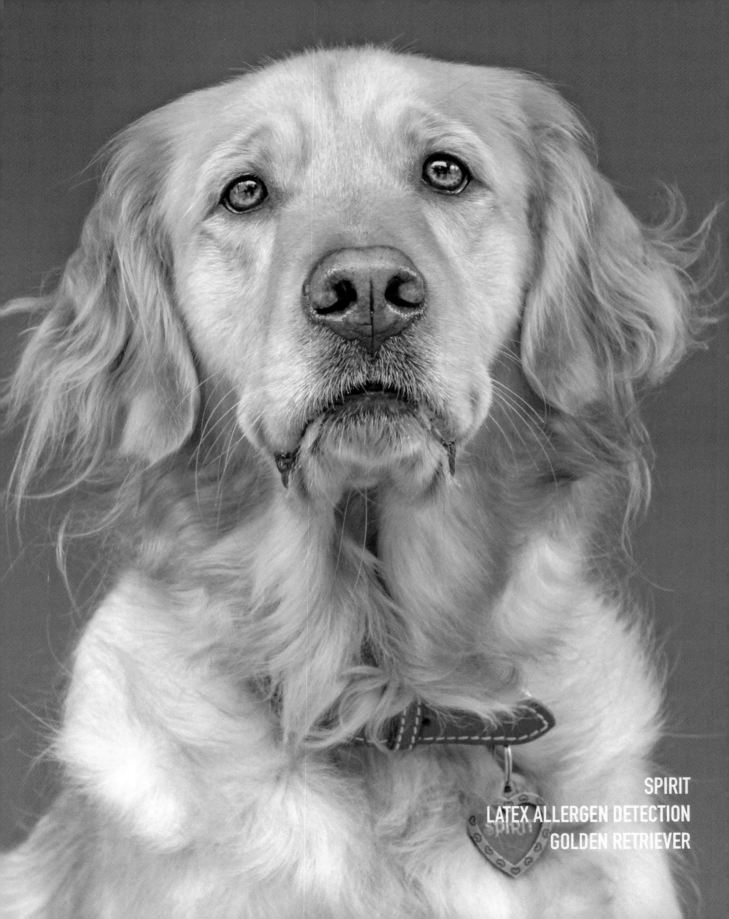

SPIRIT
LATEX ALLERGEN DETECTION
GOLDEN RETRIEVER

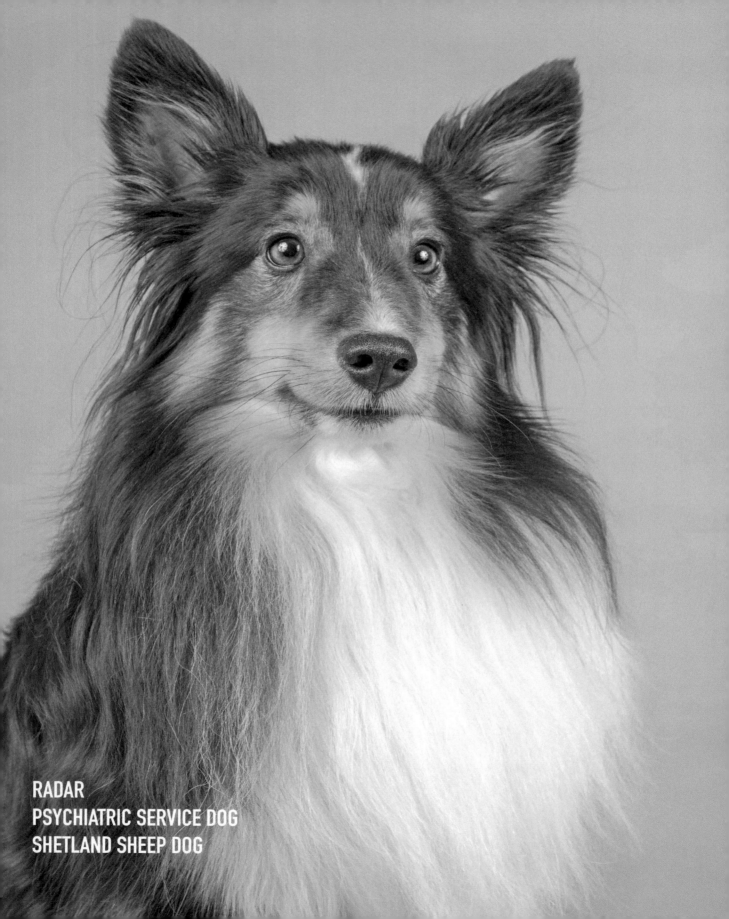

RADAR
PSYCHIATRIC SERVICE DOG
SHETLAND SHEEP DOG

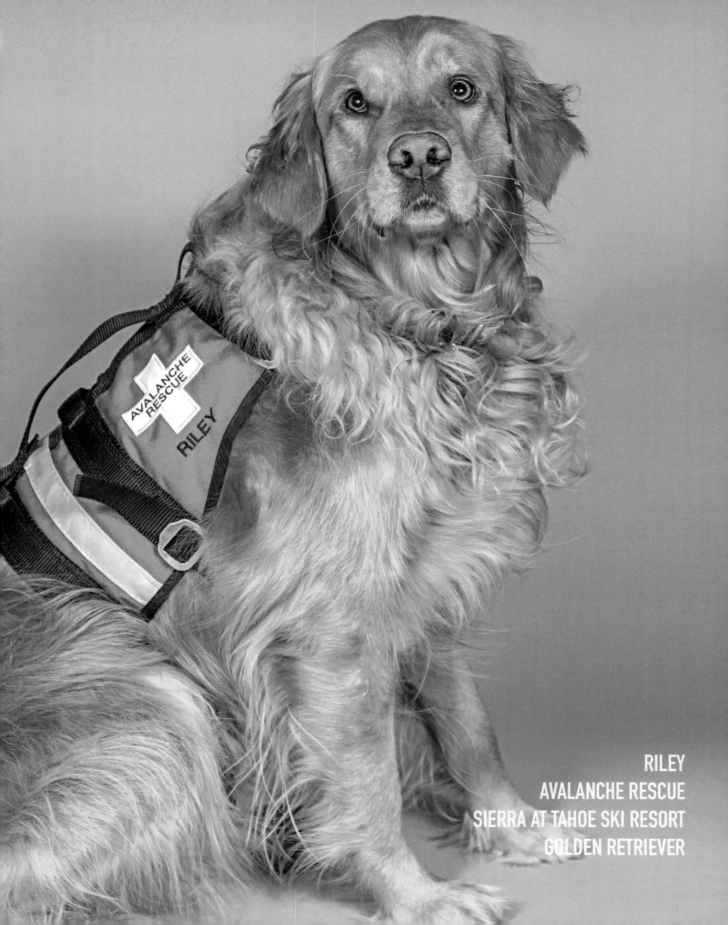

RILEY
AVALANCHE RESCUE
SIERRA AT TAHOE SKI RESORT
GOLDEN RETRIEVER

MISHKA
SLED DOG
SIBERIAN HUSKY

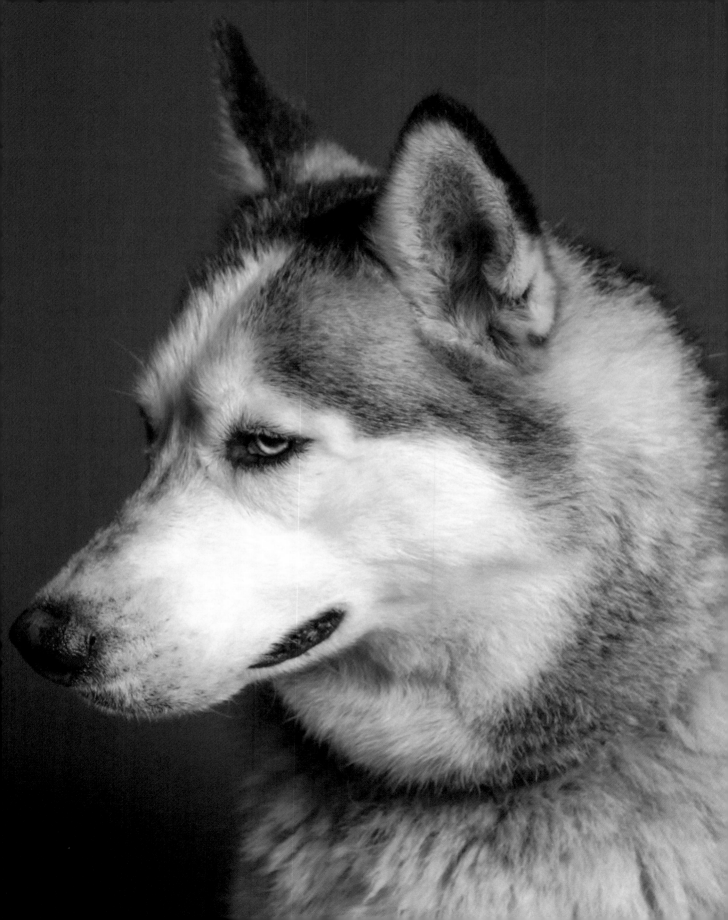

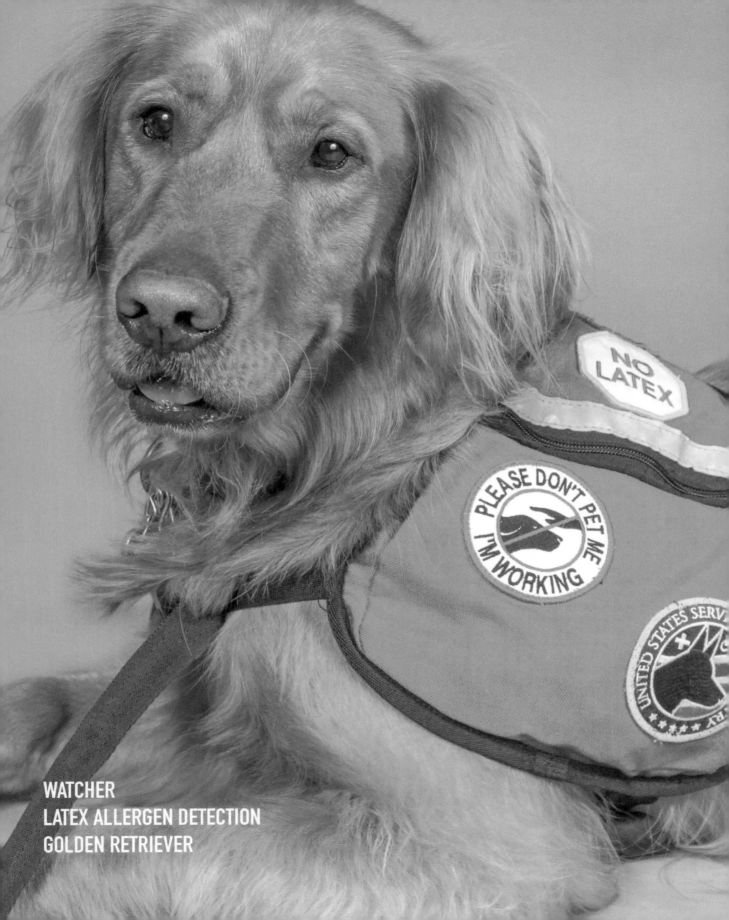

WATCHER
LATEX ALLERGEN DETECTION
GOLDEN RETRIEVER

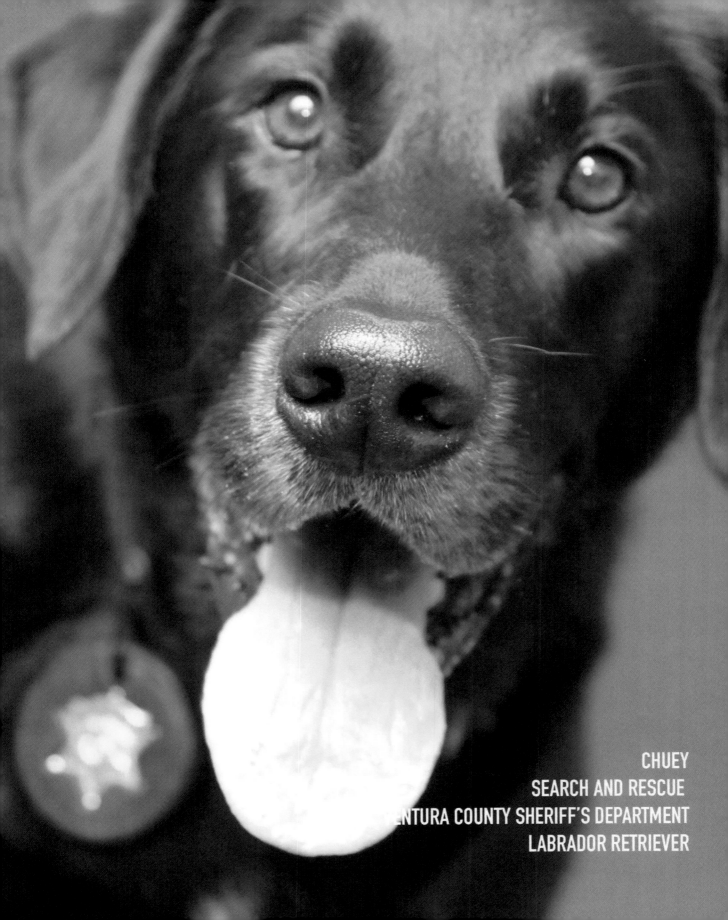

CHUEY
SEARCH AND RESCUE
VENTURA COUNTY SHERIFF'S DEPARTMENT
LABRADOR RETRIEVER

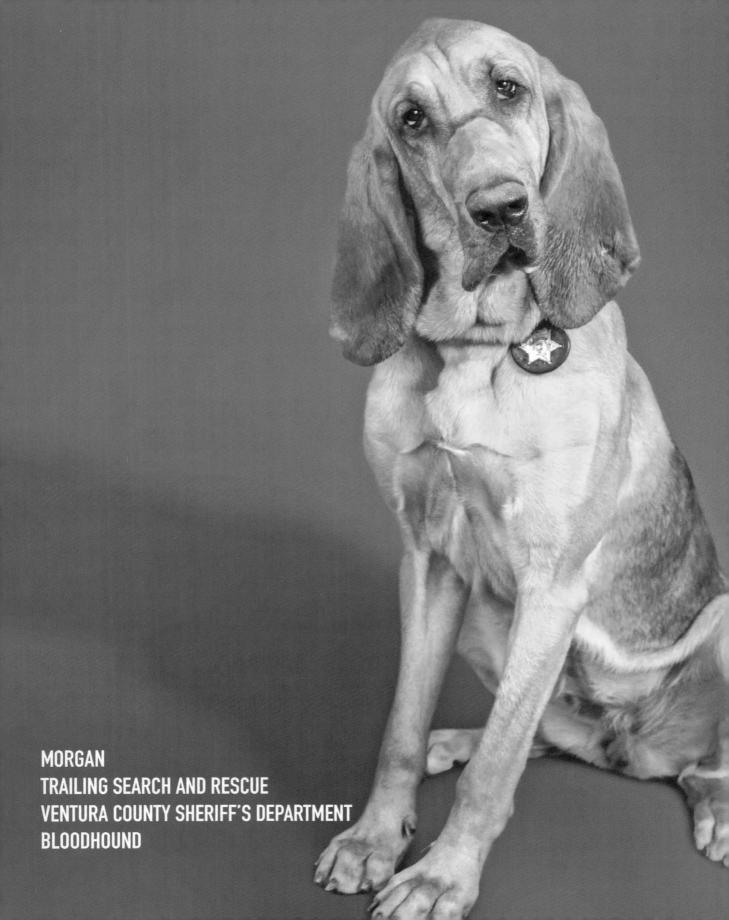

MORGAN
TRAILING SEARCH AND RESCUE
VENTURA COUNTY SHERIFF'S DEPARTMENT
BLOODHOUND

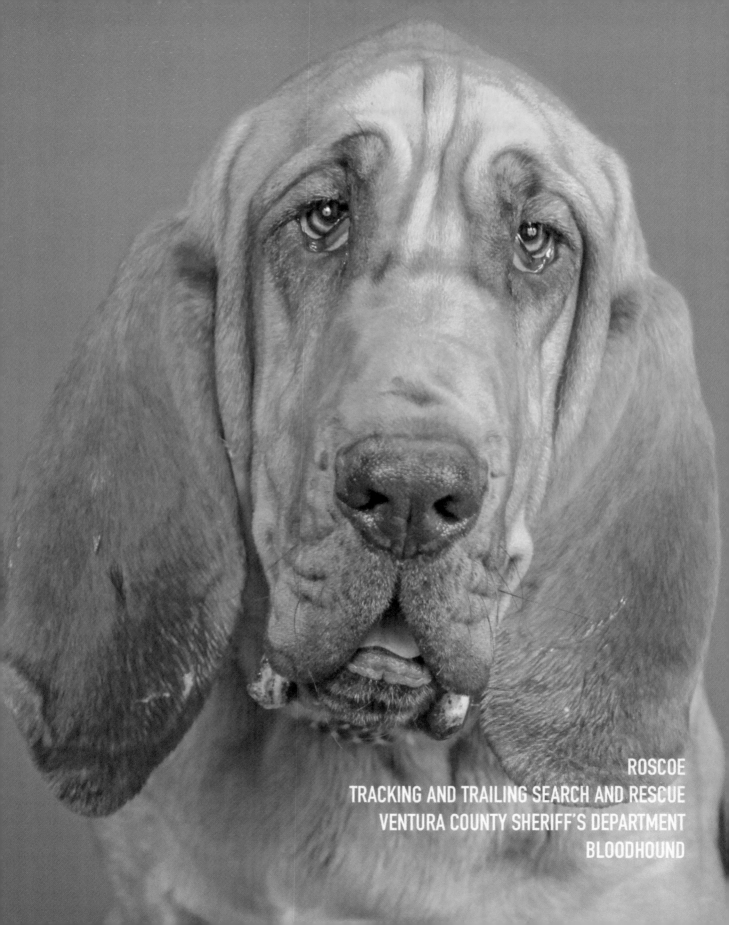

ROSCOE
TRACKING AND TRAILING SEARCH AND RESCUE
VENTURA COUNTY SHERIFF'S DEPARTMENT
BLOODHOUND

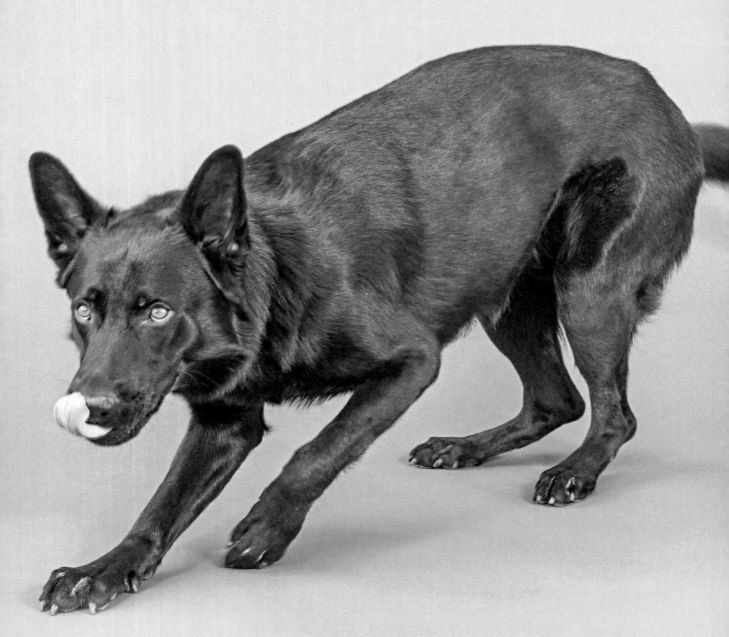

RENZO
PERSONAL PROTECTION DOG
TACKETT SERVICE DOGS
GERMAN SHEPHERD

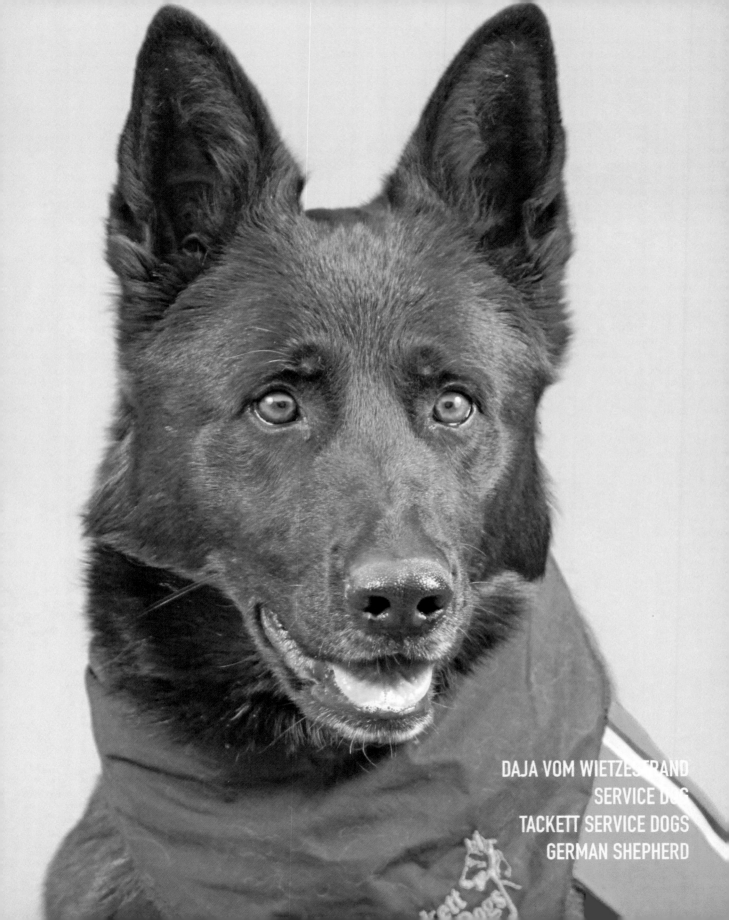

DAJA VOM WIETZESTRAND
SERVICE DOGS
TACKETT SERVICE DOGS
GERMAN SHEPHERD

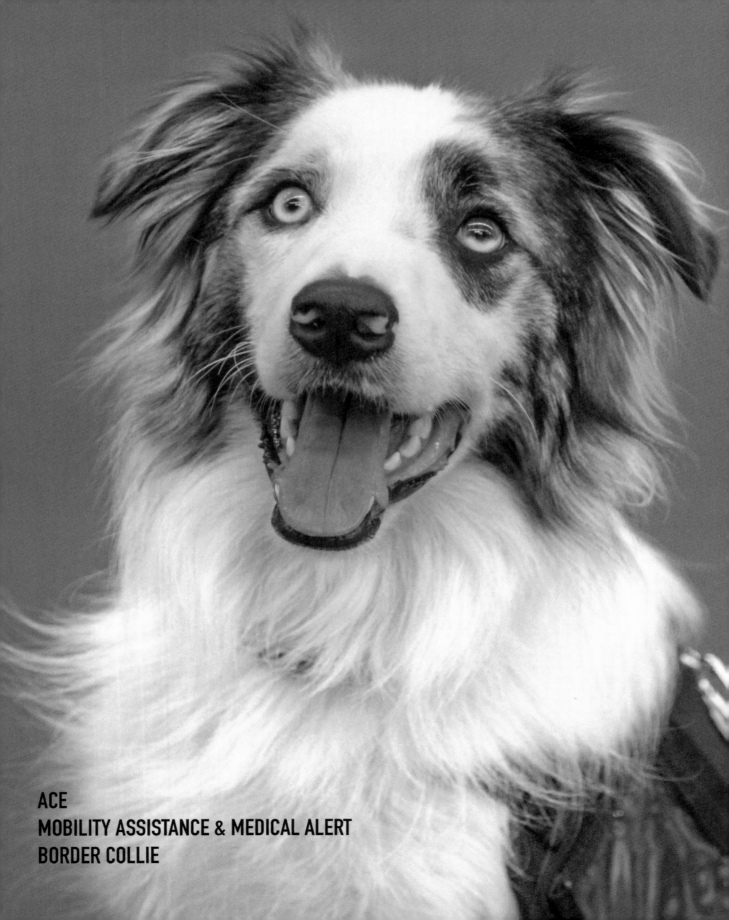

ACE
MOBILITY ASSISTANCE & MEDICAL ALERT
BORDER COLLIE

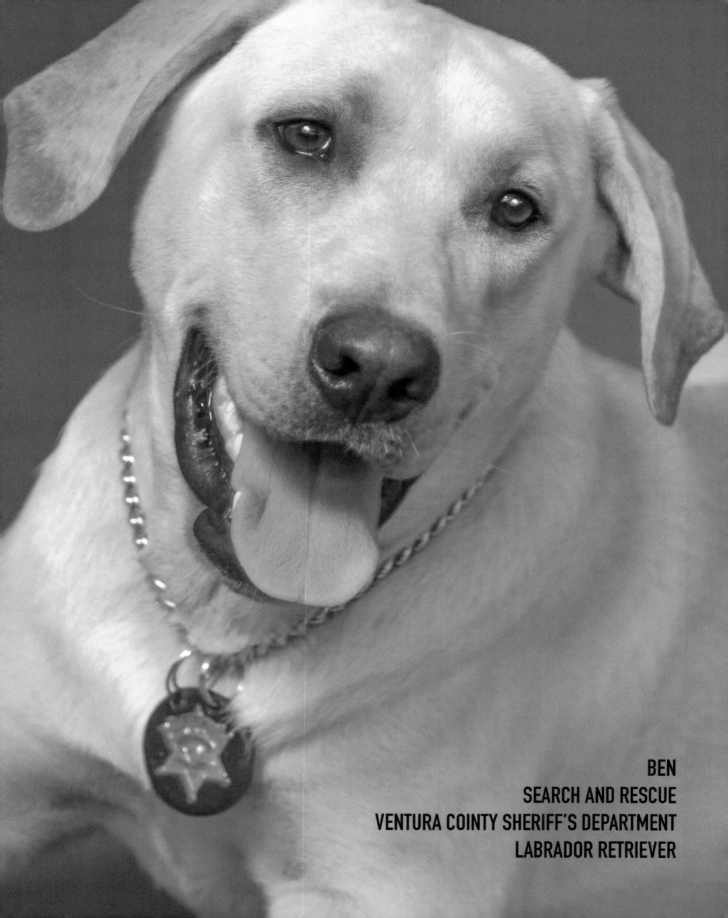

BEN
SEARCH AND RESCUE
VENTURA COINTY SHERIFF'S DEPARTMENT
LABRADOR RETRIEVER

Canine Companions for Independence gave me the confidence to live an independent life.

- Auggie's Handler

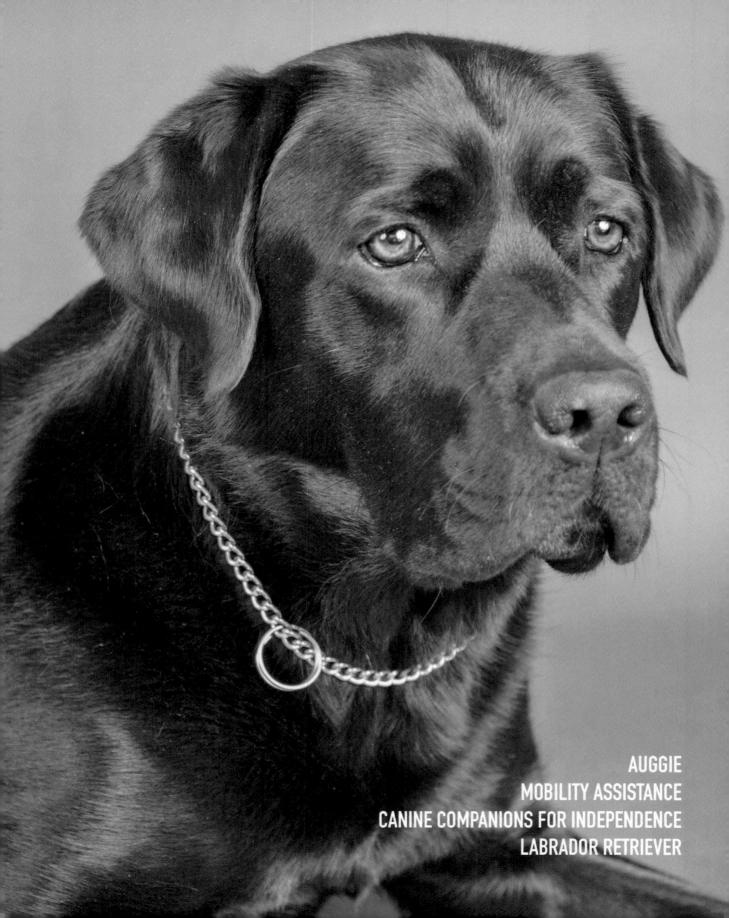

AUGGIE
MOBILITY ASSISTANCE
CANINE COMPANIONS FOR INDEPENDENCE
LABRADOR RETRIEVER

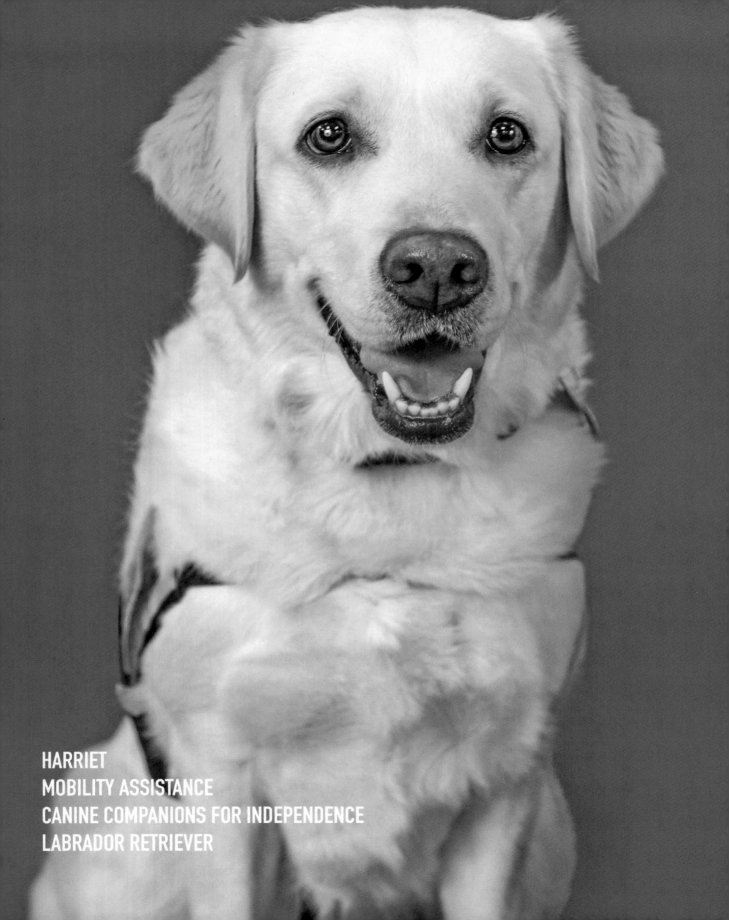

HARRIET
MOBILITY ASSISTANCE
CANINE COMPANIONS FOR INDEPENDENCE
LABRADOR RETRIEVER

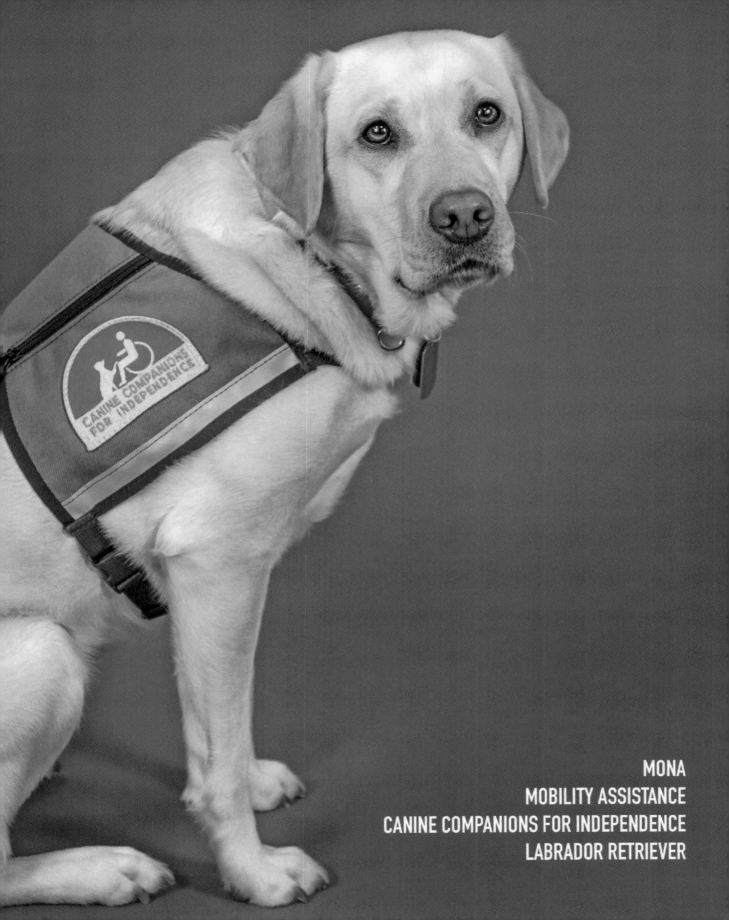

MONA
MOBILITY ASSISTANCE
CANINE COMPANIONS FOR INDEPENDENCE
LABRADOR RETRIEVER

STACEY MAE
THERAPY DOG
THE TEDDY BEAR PROJECT
GREATER SWISS MOUNTAIN DOG

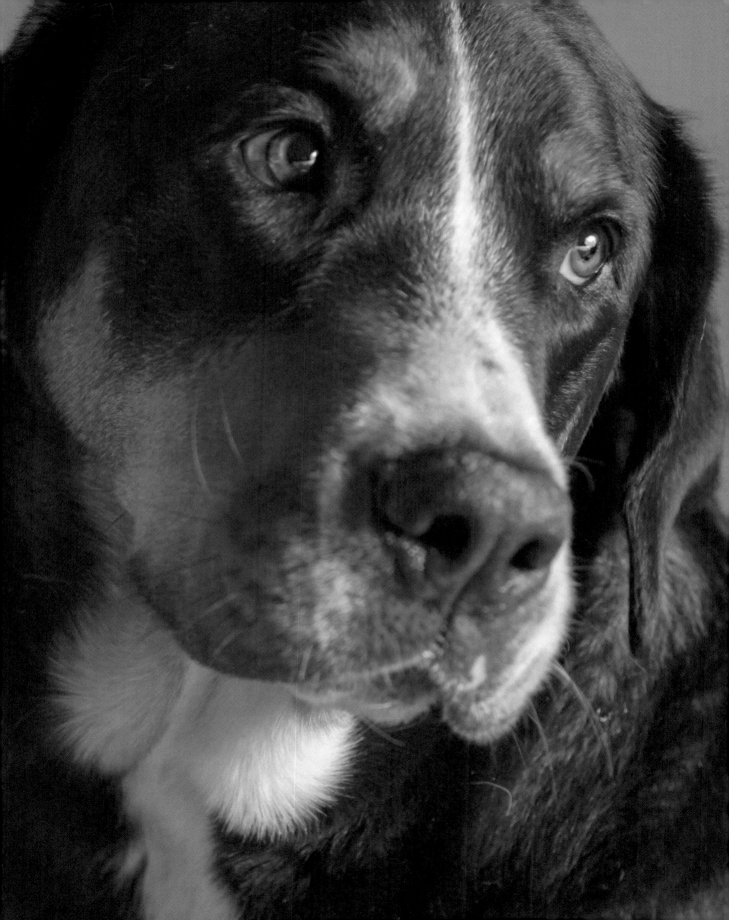

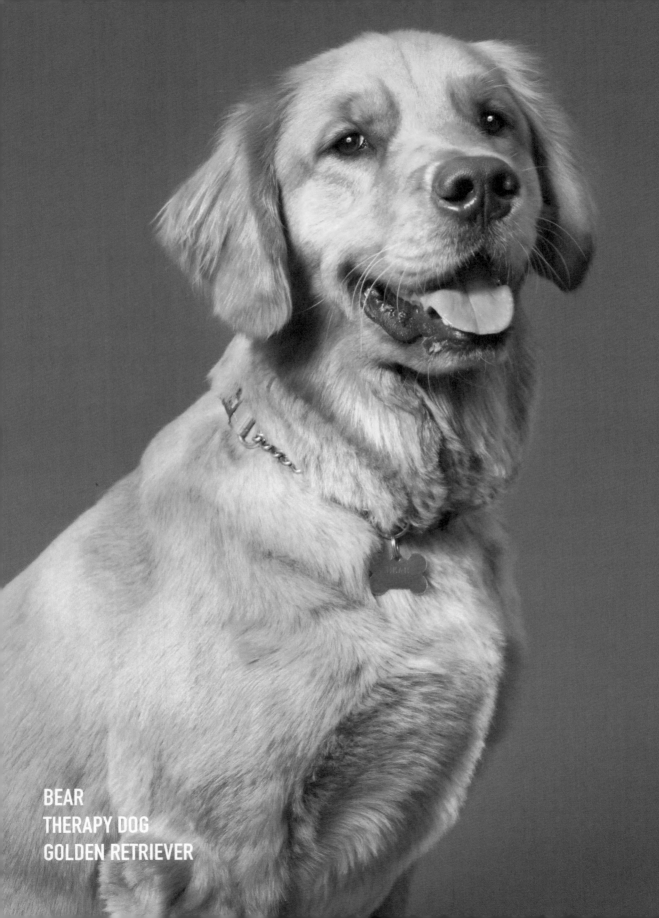

BEAR
THERAPY DOG
GOLDEN RETRIEVER

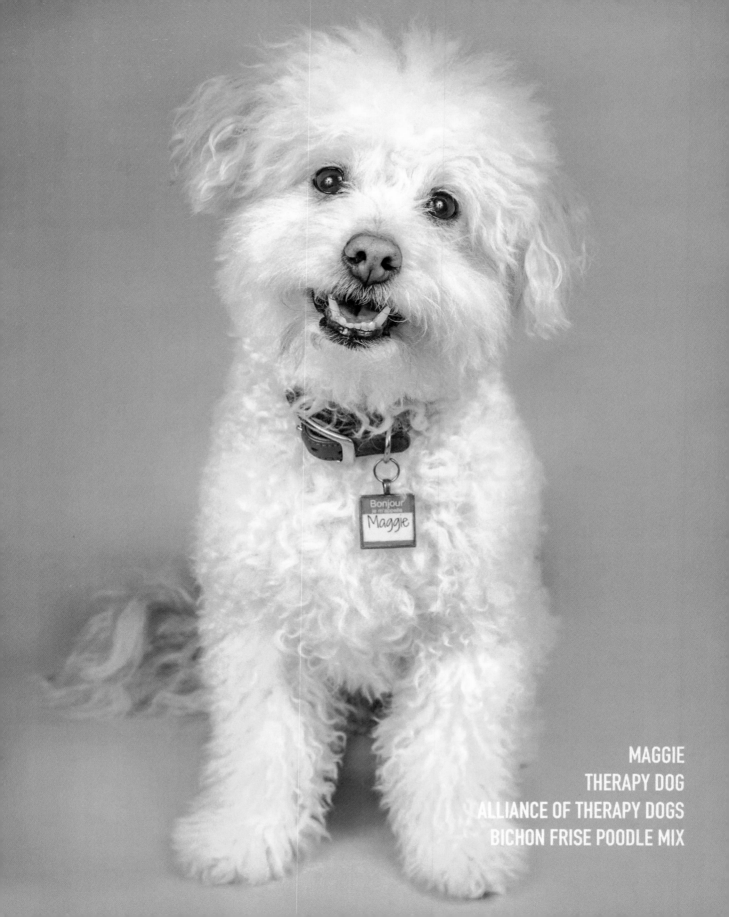

MAGGIE
THERAPY DOG
ALLIANCE OF THERAPY DOGS
BICHON FRISE POODLE MIX

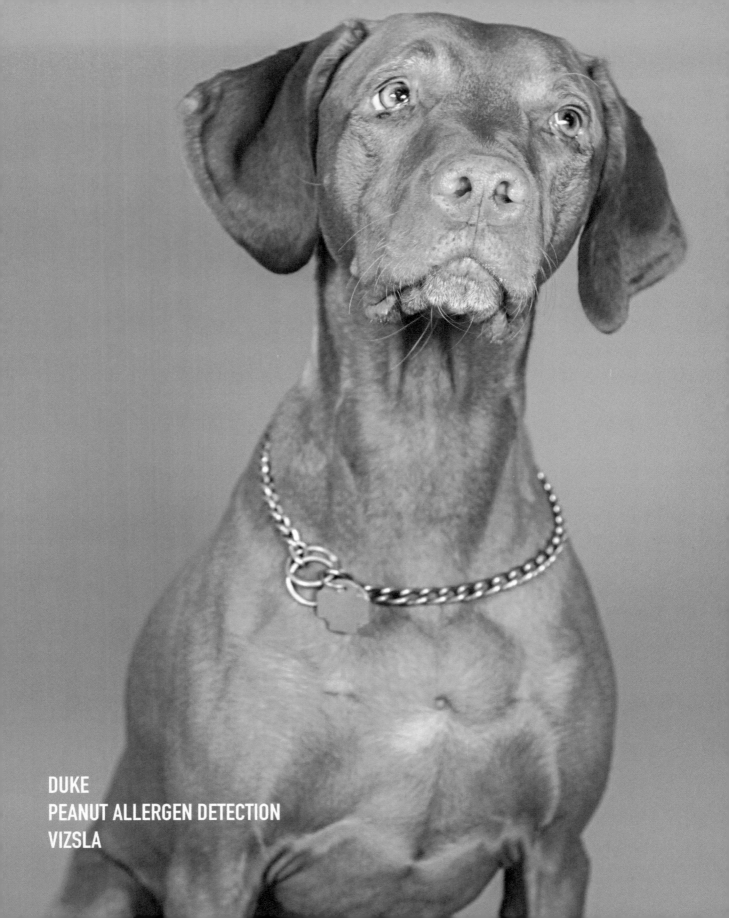

DUKE
PEANUT ALLERGEN DETECTION
VIZSLA

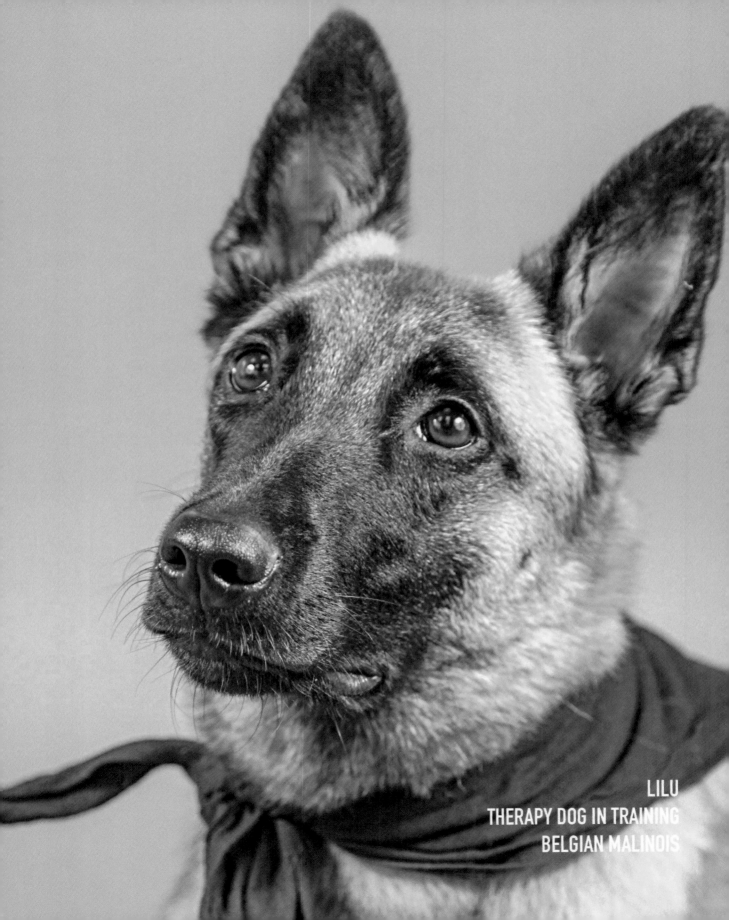

LILU
THERAPY DOG IN TRAINING
BELGIAN MALINOIS

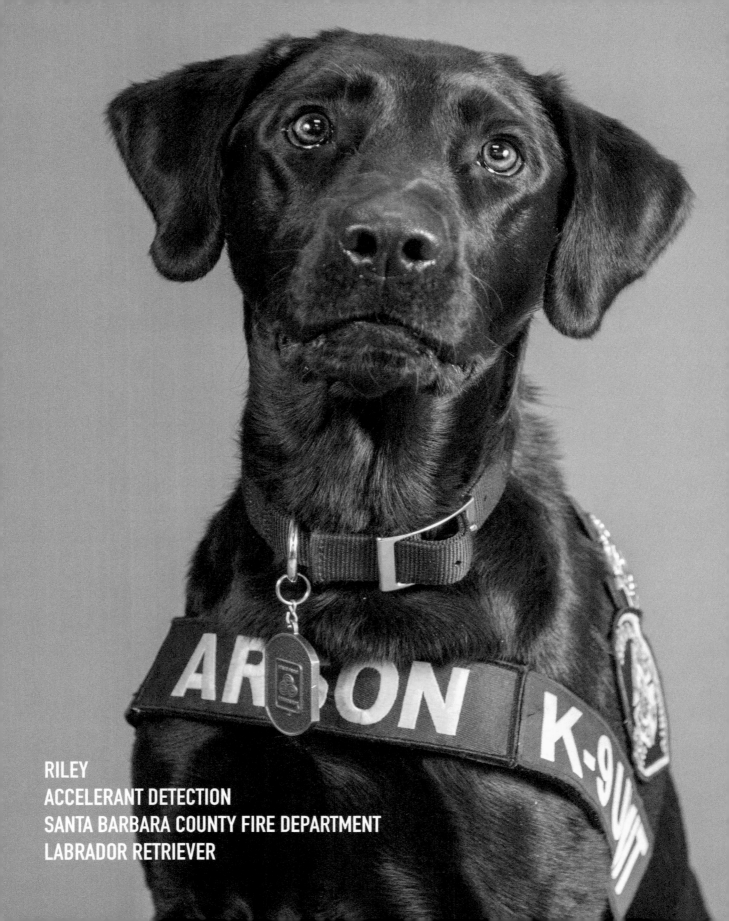

RILEY
ACCELERANT DETECTION
SANTA BARBARA COUNTY FIRE DEPARTMENT
LABRADOR RETRIEVER

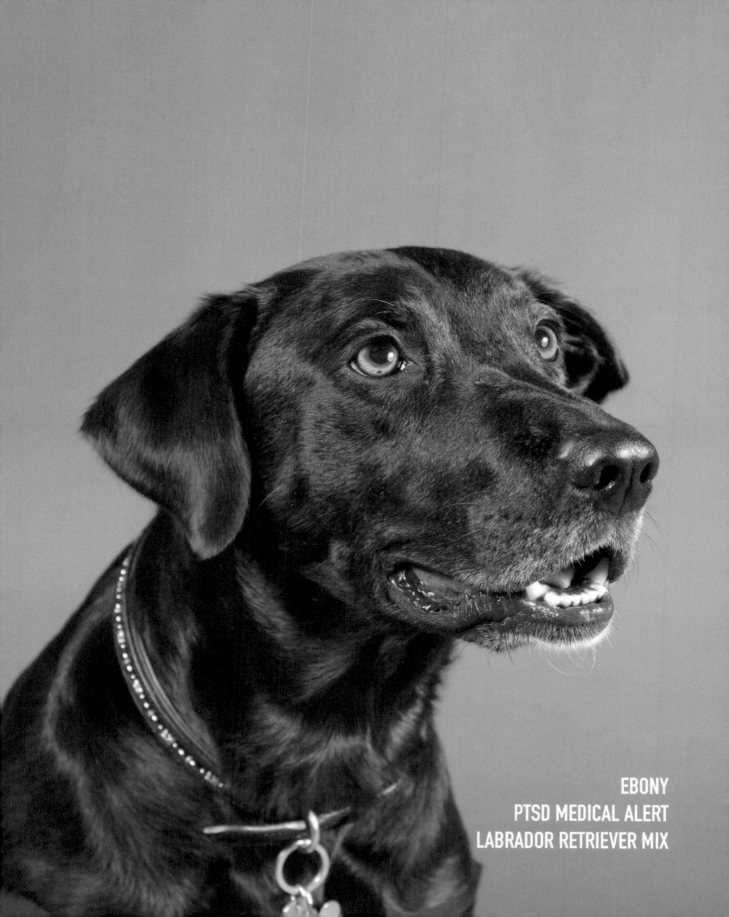

EBONY
PTSD MEDICAL ALERT
LABRADOR RETRIEVER MIX

MWD CHEF H067 is a true American Hero. Chef served for 5 years as an explosives detection/patrol dog. During his career he has served two tours in Iraq and one in Djibouti.

- Chef's Handler

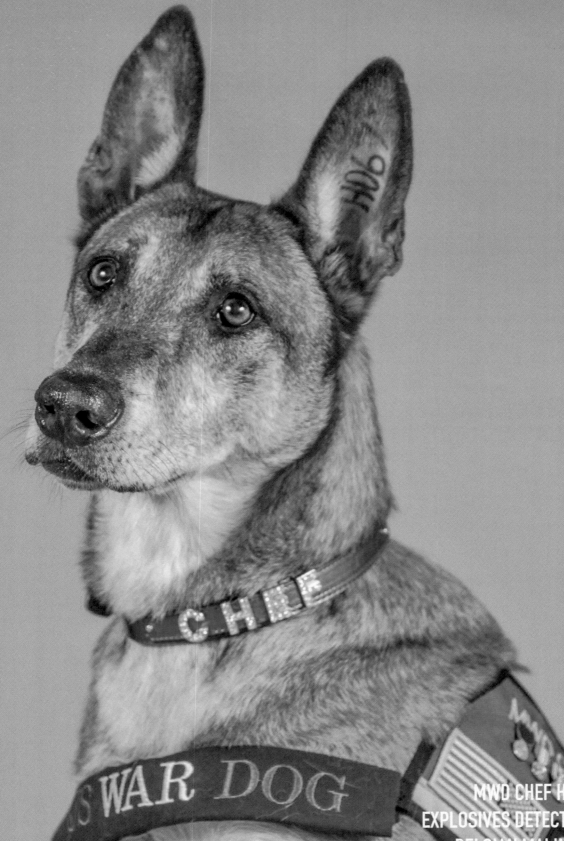

CHIEF

U.S WAR DOG

MWD CHEF H067
EXPLOSIVES DETECTION
BELGIAN MALINOIS

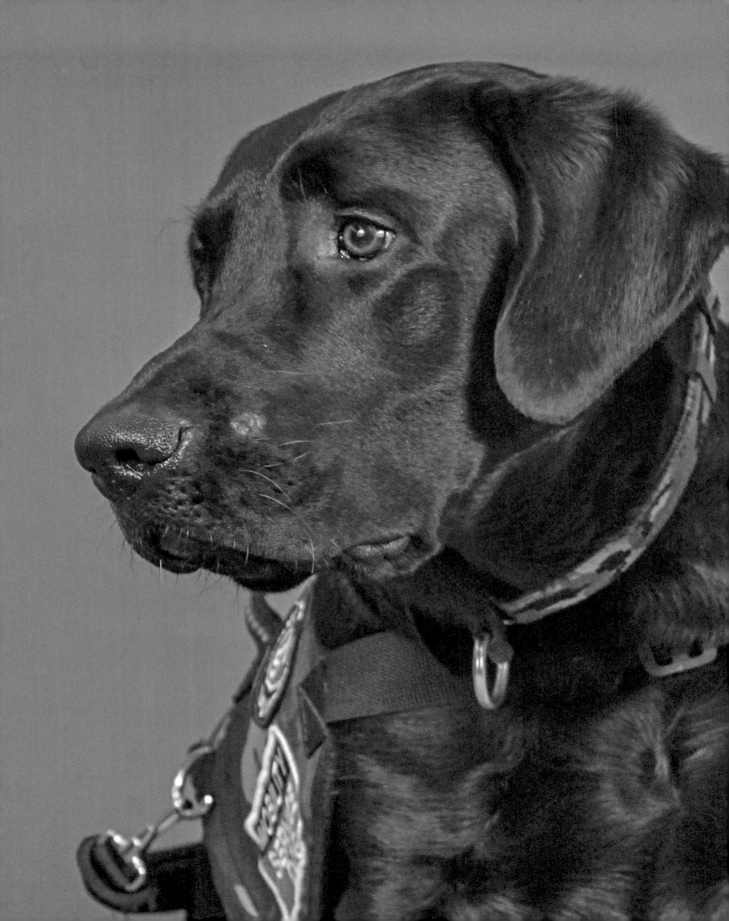

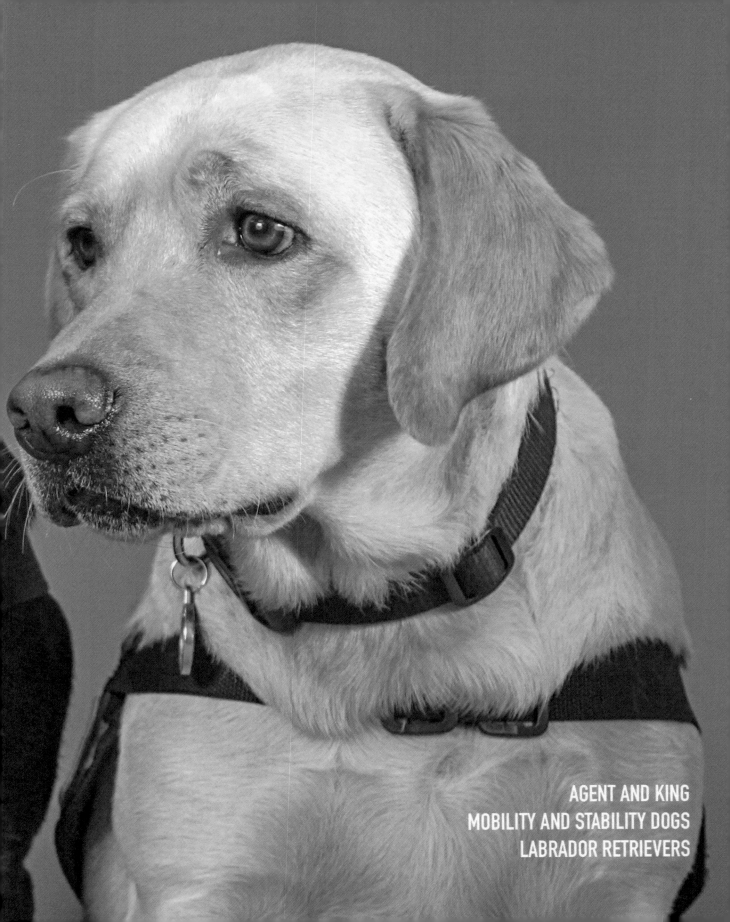

AGENT AND KING
MOBILITY AND STABILITY DOGS
LABRADOR RETRIEVERS

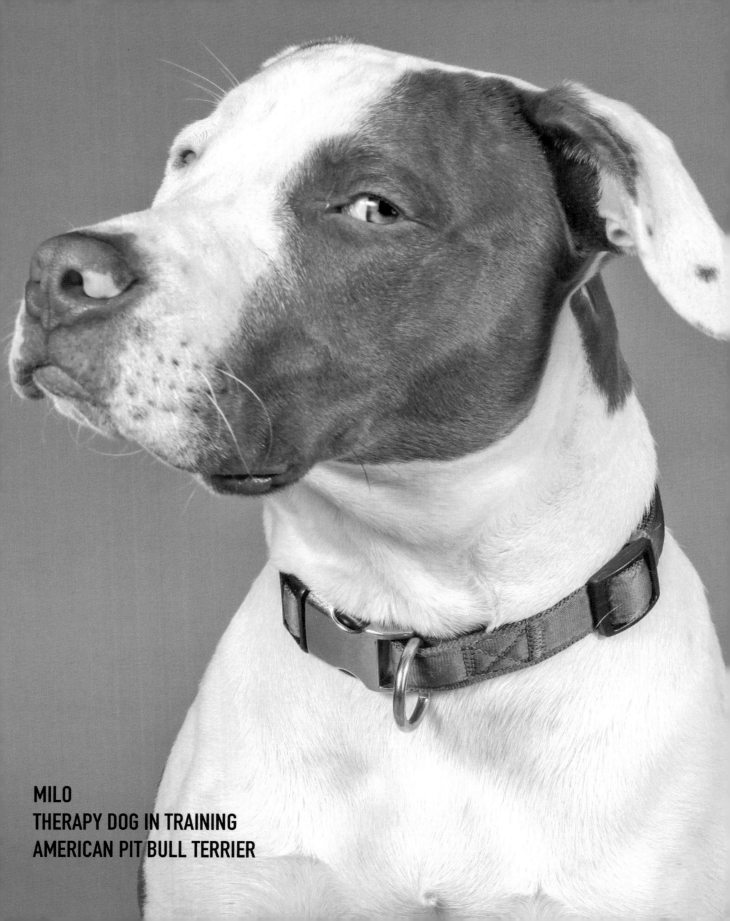

MILO
THERAPY DOG IN TRAINING
AMERICAN PIT BULL TERRIER

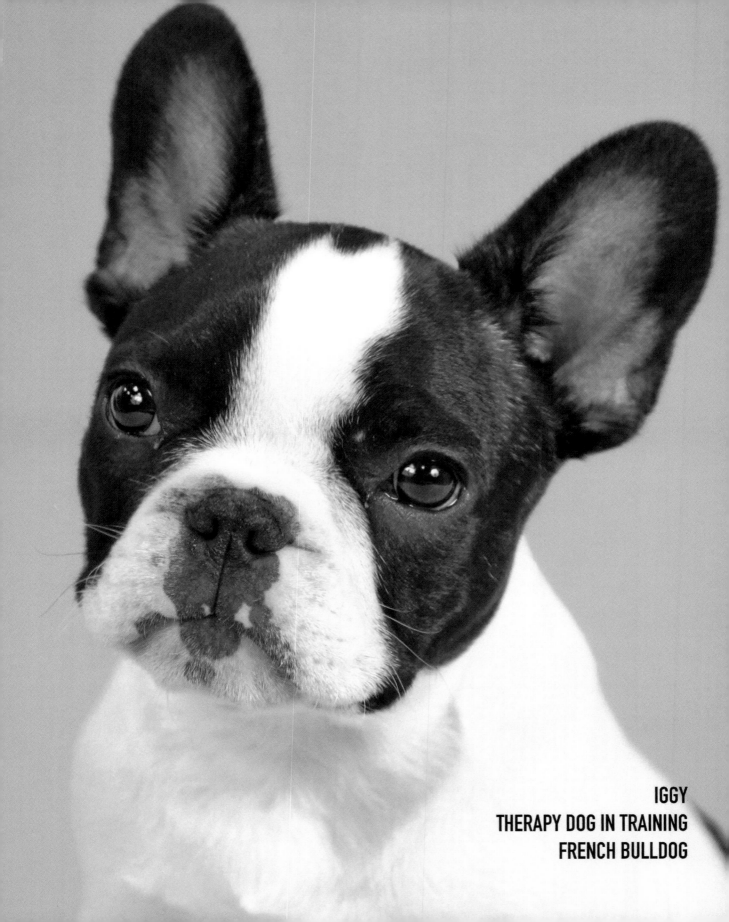

IGGY
THERAPY DOG IN TRAINING
FRENCH BULLDOG

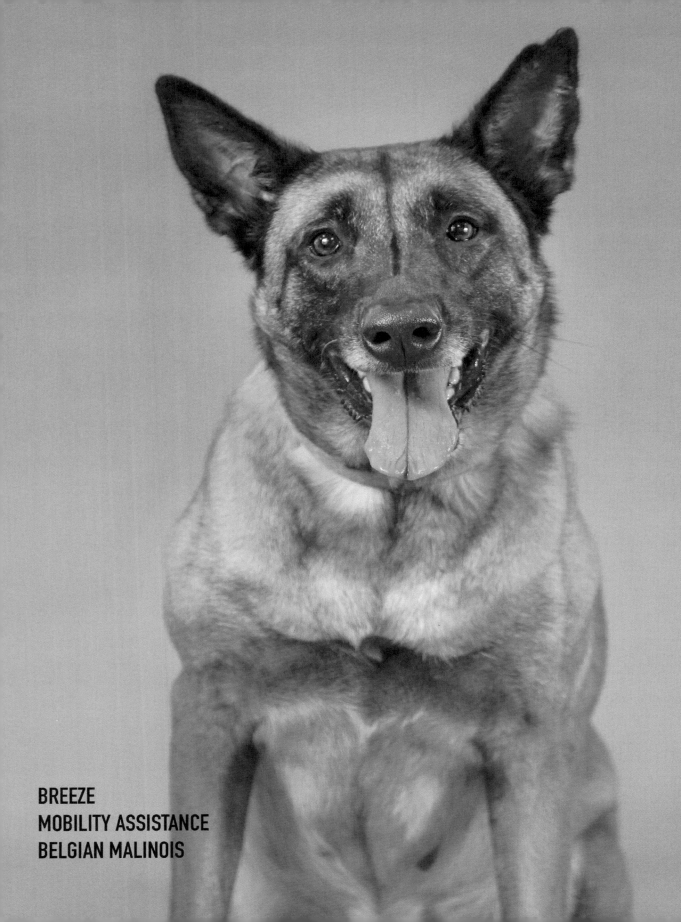

BREEZE
MOBILITY ASSISTANCE
BELGIAN MALINOIS

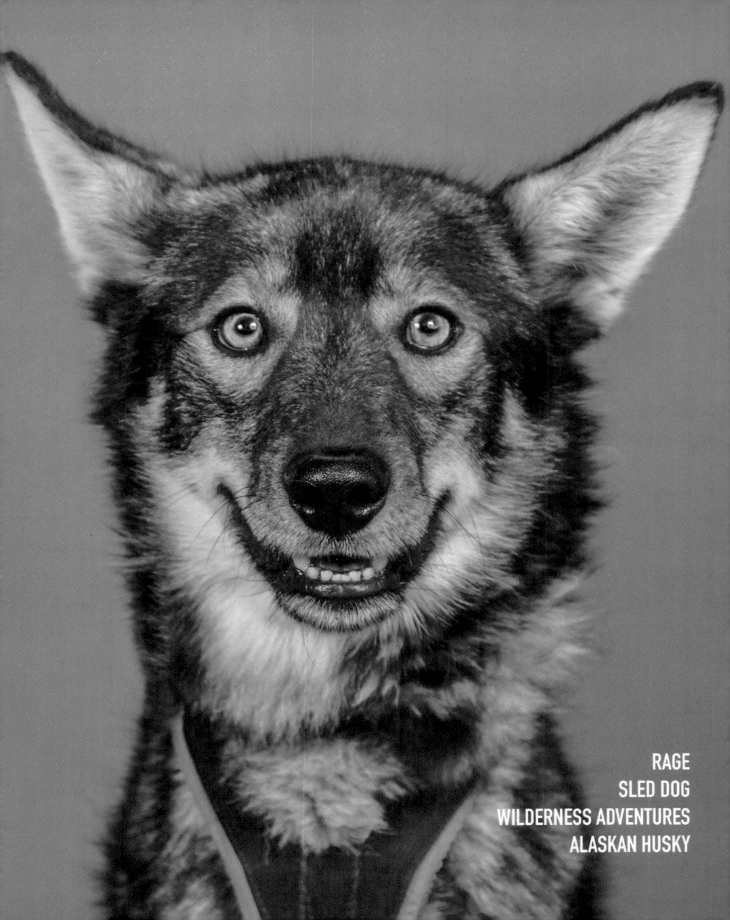

RAGE
SLED DOG
WILDERNESS ADVENTURES
ALASKAN HUSKY

LEXI
MOBILITY ASSISTANCE & BLOOD DONOR
SIBERIAN HUSKY PIT BULL MIX

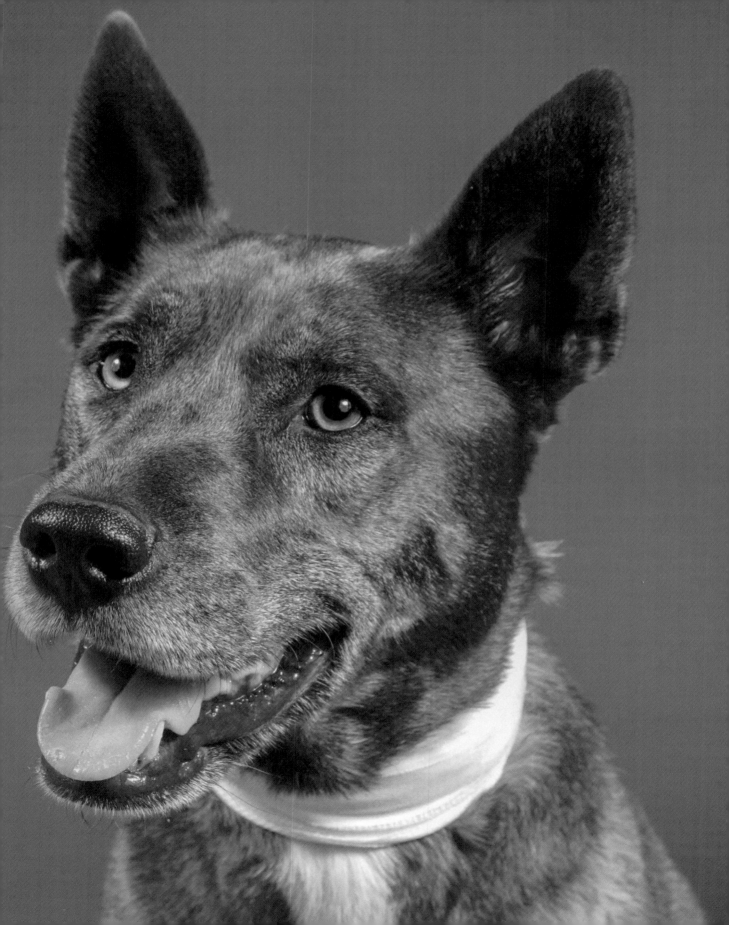

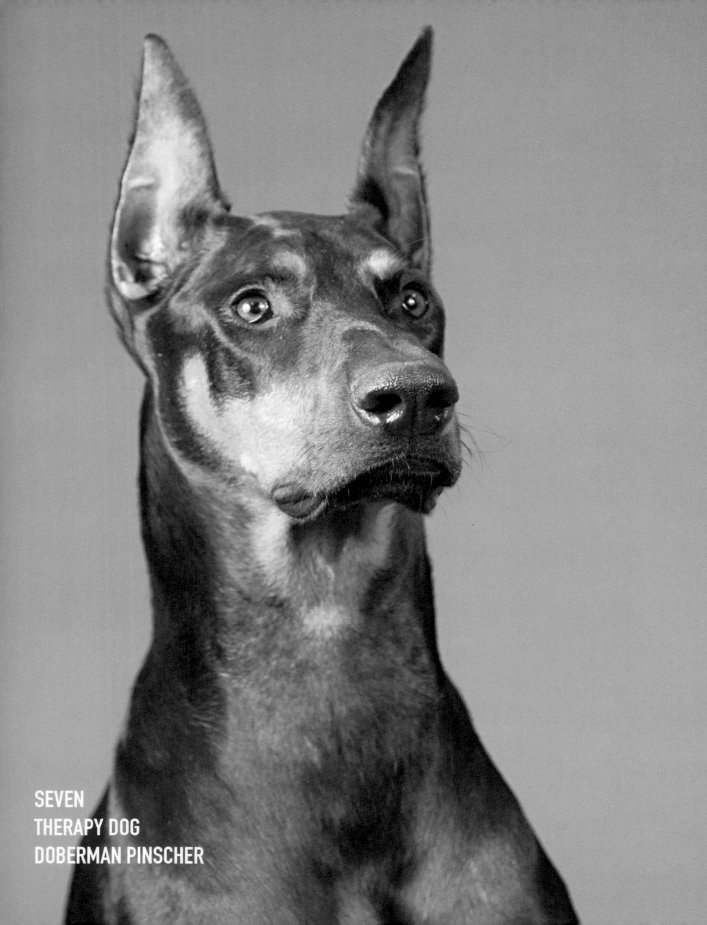

SEVEN
THERAPY DOG
DOBERMAN PINSCHER

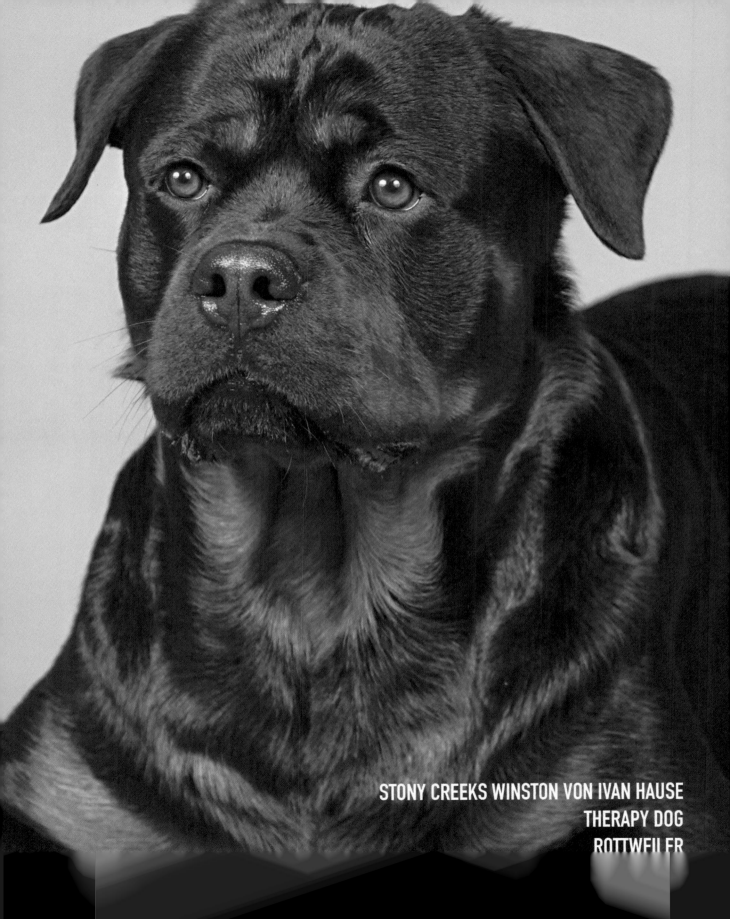

STONY CREEKS WINSTON VON IVAN HAUSE
THERAPY DOG
ROTTWEILER

As I was finishing up my two year service as a Peace Corps volunteer in Vanuatu I asked Kumala if she wa ted to come home with me. She stood up and walked over to me, sat down, put her paw on my leg and licked me. That is when I knew we were going to be together forever.

- Kumala's Handler

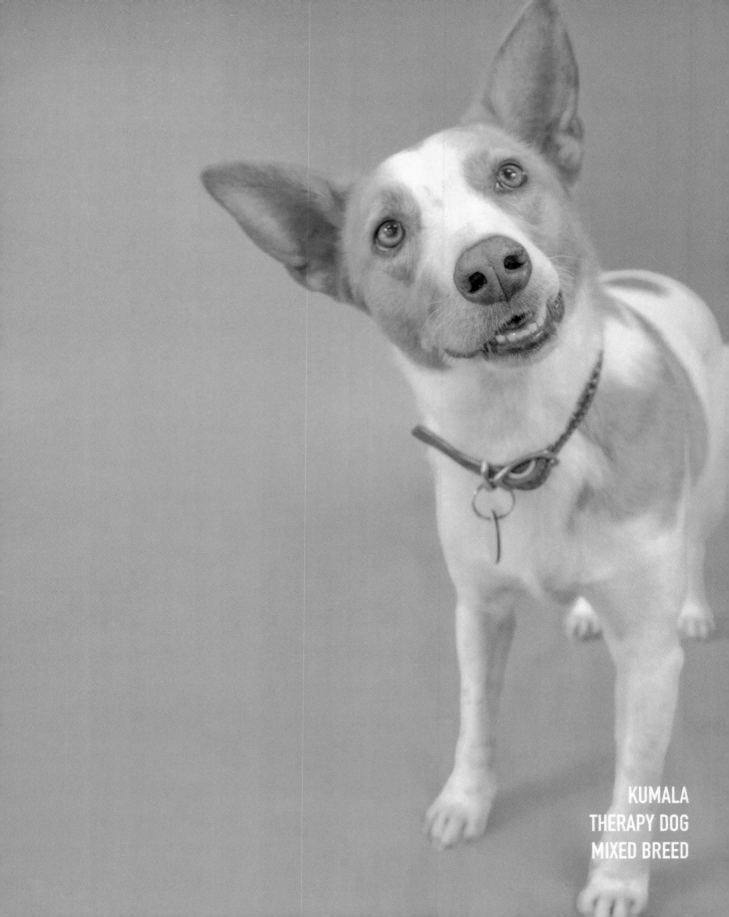

KUMALA
THERAPY DOG
MIXED BREED

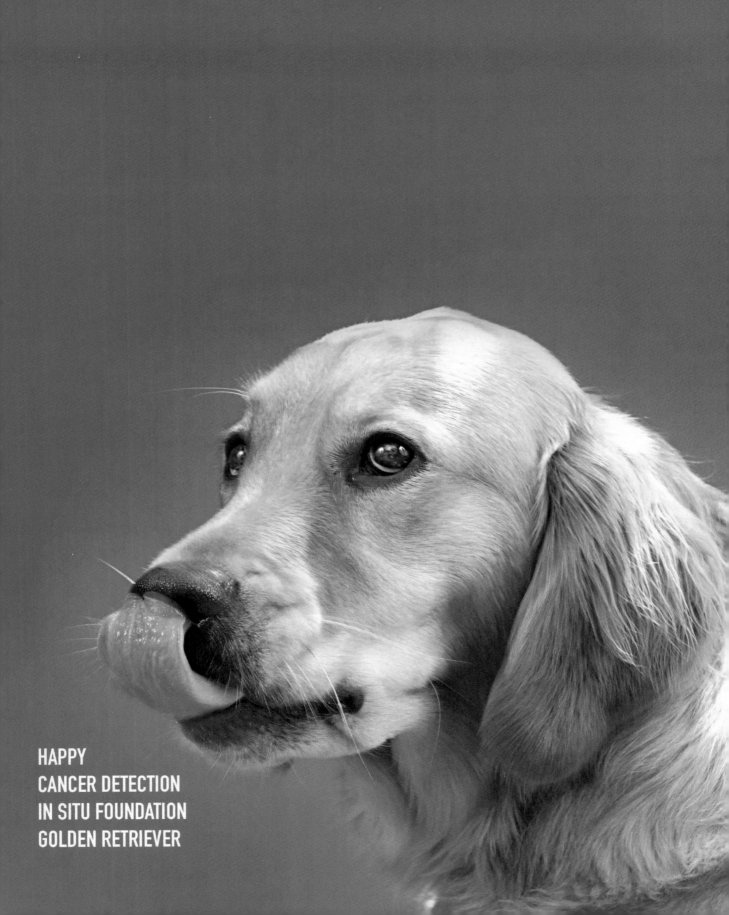

HAPPY
CANCER DETECTION
IN SITU FOUNDATION
GOLDEN RETRIEVER

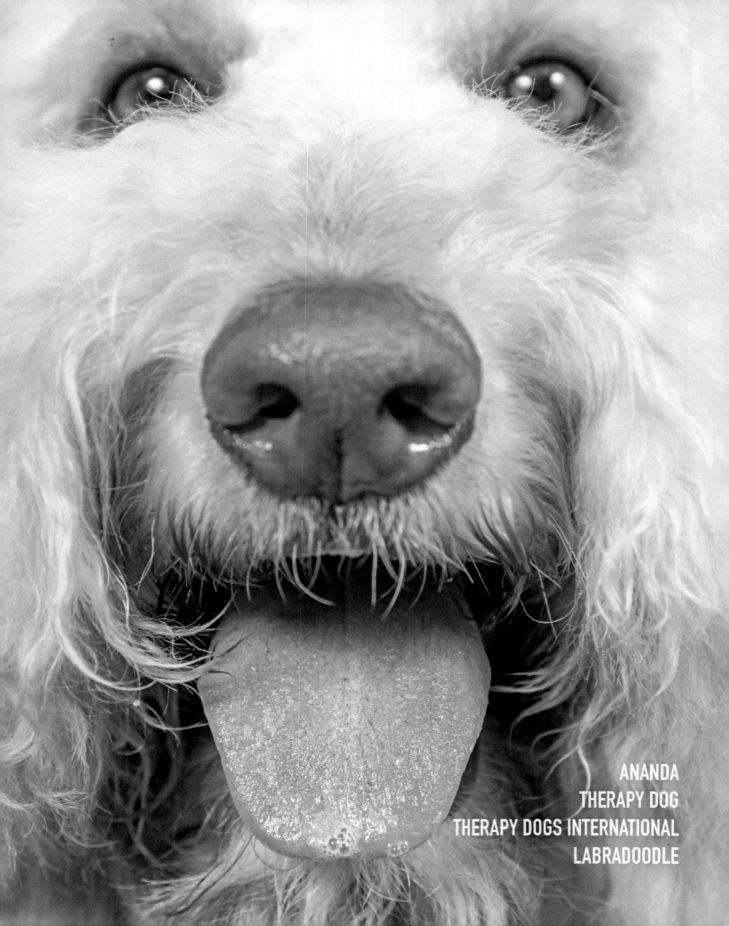

ANANDA
THERAPY DOG
THERAPY DOGS INTERNATIONAL
LABRADOODLE

FELICA
SLED DOG
SIBERIAN HUSKY

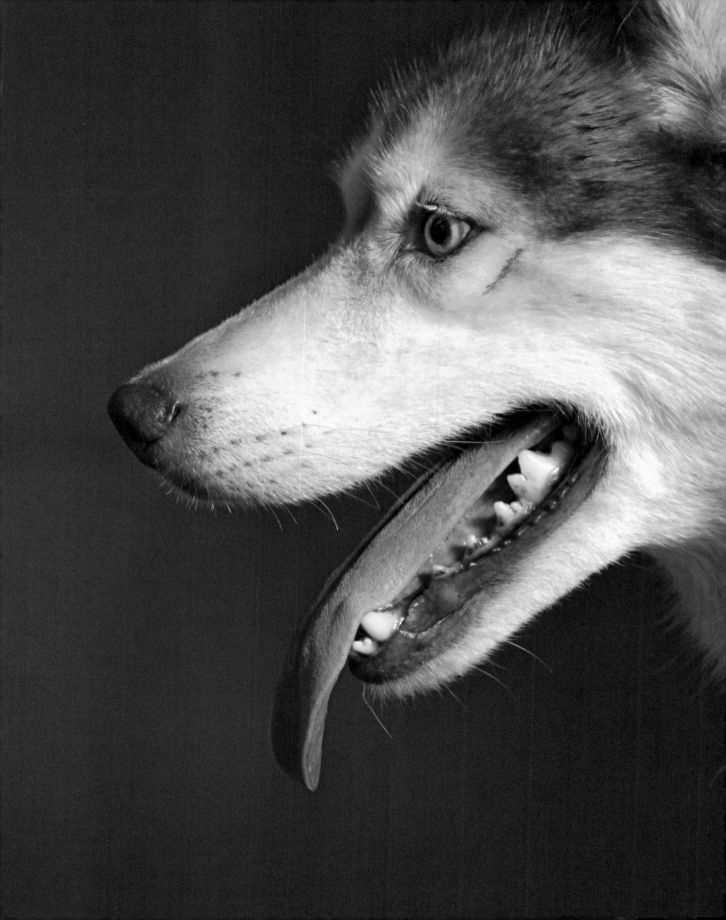

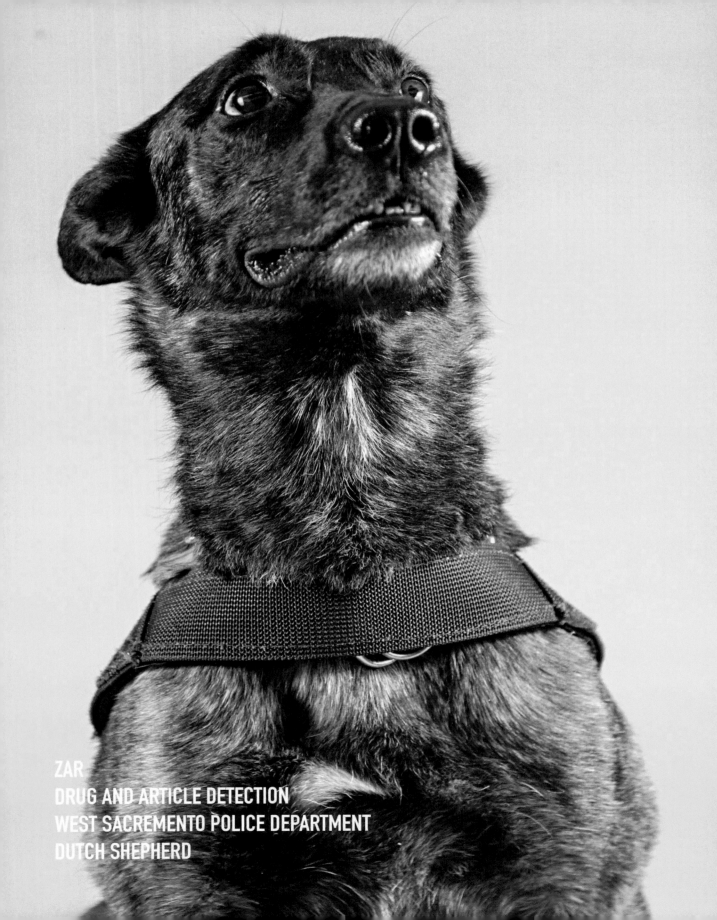

ZAR
DRUG AND ARTICLE DETECTION
WEST SACREMENTO POLICE DEPARTMENT
DUTCH SHEPHERD

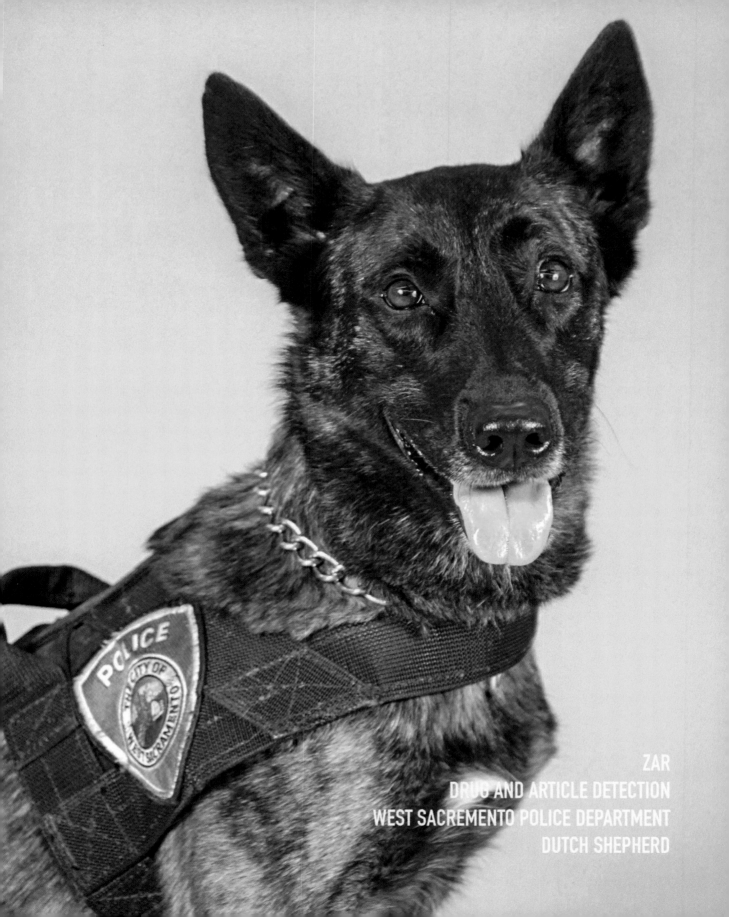

ZAR
DRUG AND ARTICLE DETECTION
WEST SACREMENTO POLICE DEPARTMENT
DUTCH SHEPHERD

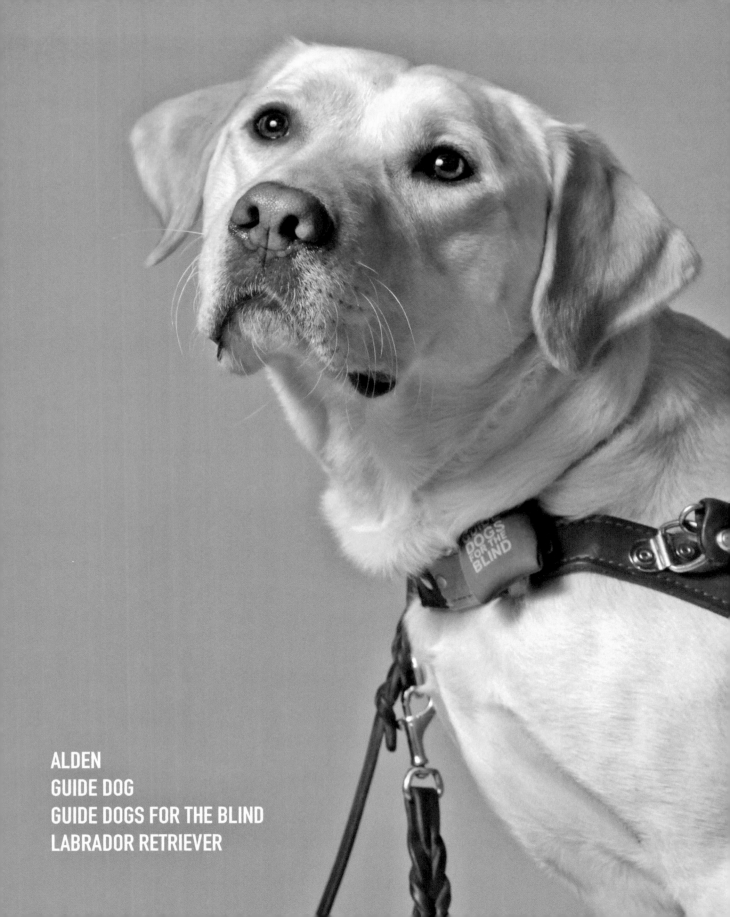

ALDEN
GUIDE DOG
GUIDE DOGS FOR THE BLIND
LABRADOR RETRIEVER

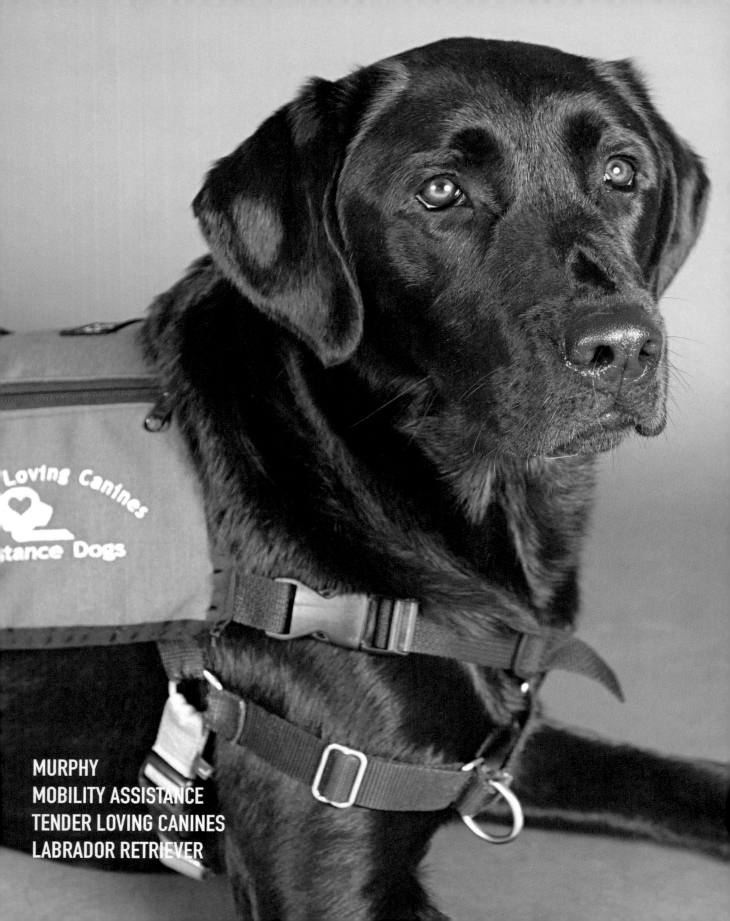

MURPHY
MOBILITY ASSISTANCE
TENDER LOVING CANINES
LABRADOR RETRIEVER

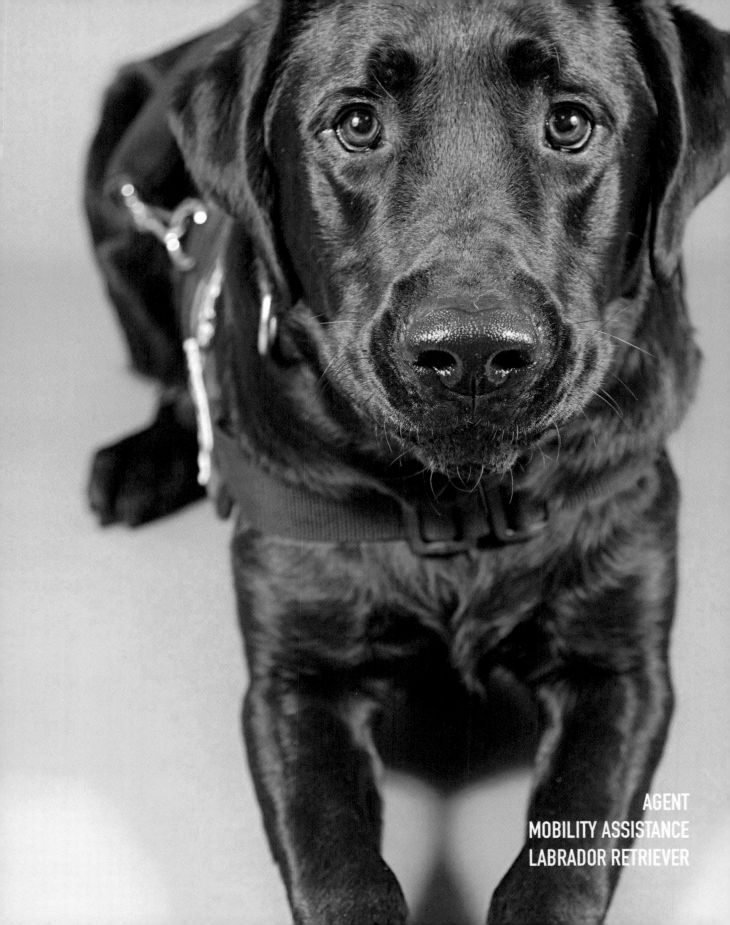

AGENT
MOBILITY ASSISTANCE
LABRADOR RETRIEVER

Baby was rescued from an animal shelter and given over 800 hours of training to get certified as a bedbug detection dog. Baby has been very busy inspecting hotels, apartments, residential homes, nursing homes, commercial properties, office buildings, and housing authorities.

- Round The Clock Pest Control

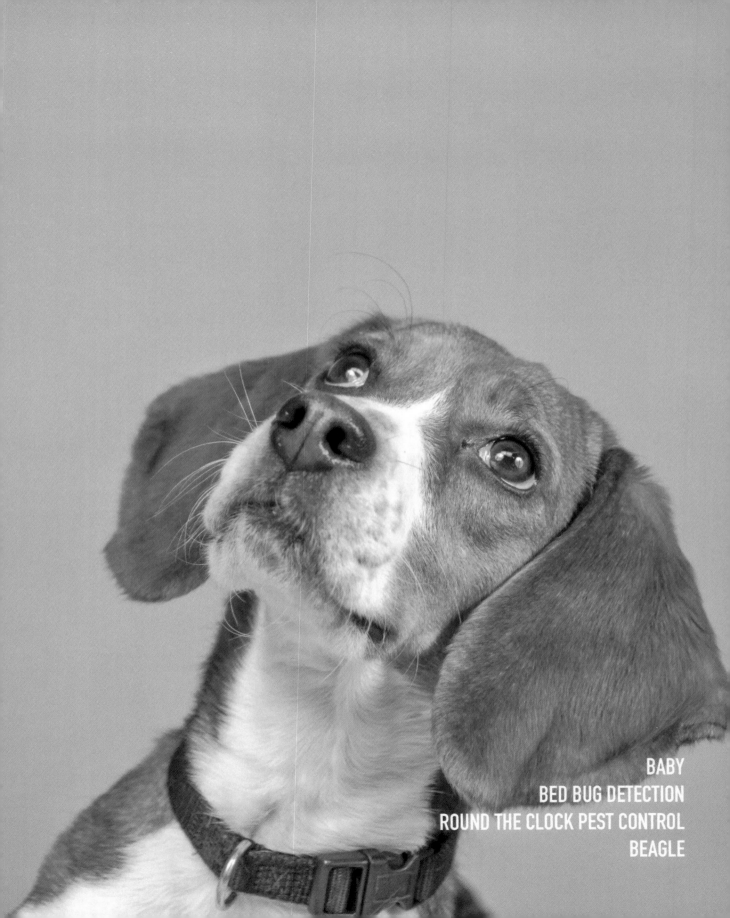

BABY
BED BUG DETECTION
ROUND THE CLOCK PEST CONTROL
BEAGLE

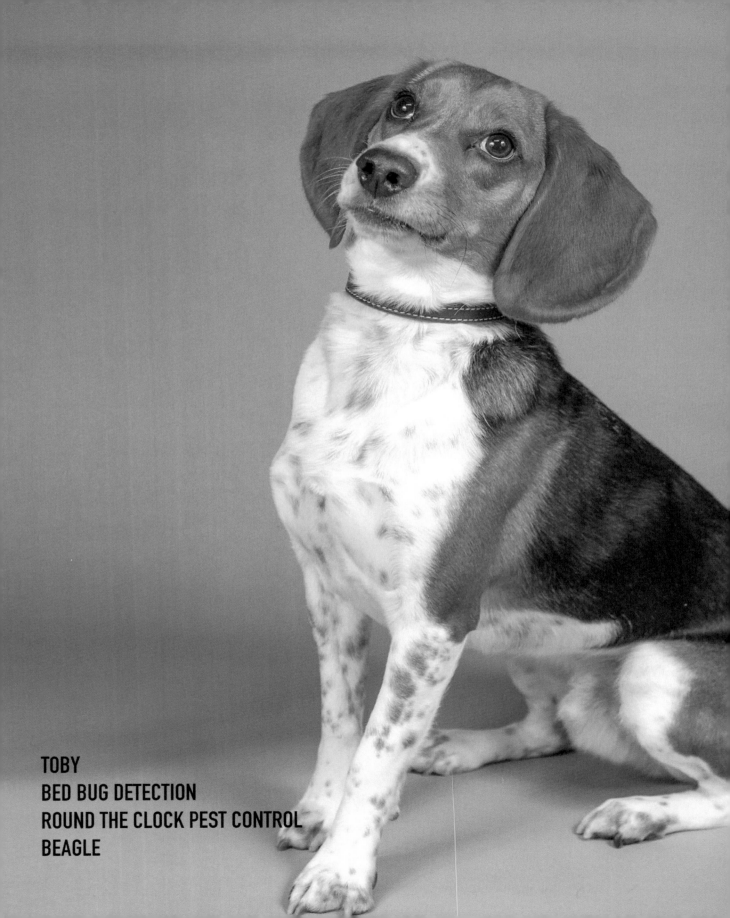

TOBY
BED BUG DETECTION
ROUND THE CLOCK PEST CONTROL
BEAGLE

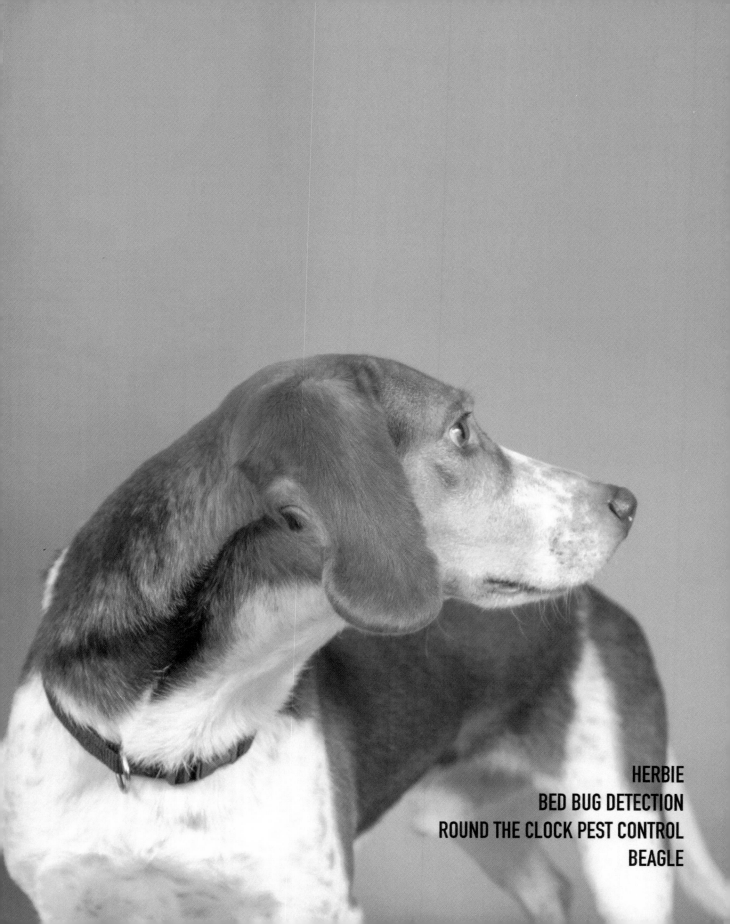

HERBIE
BED BUG DETECTION
ROUND THE CLOCK PEST CONTROL
BEAGLE

IKE
MOBILITY ASSISTANCE
CANINE SUPPORT TEAMS, INC.
LABRADOODLE

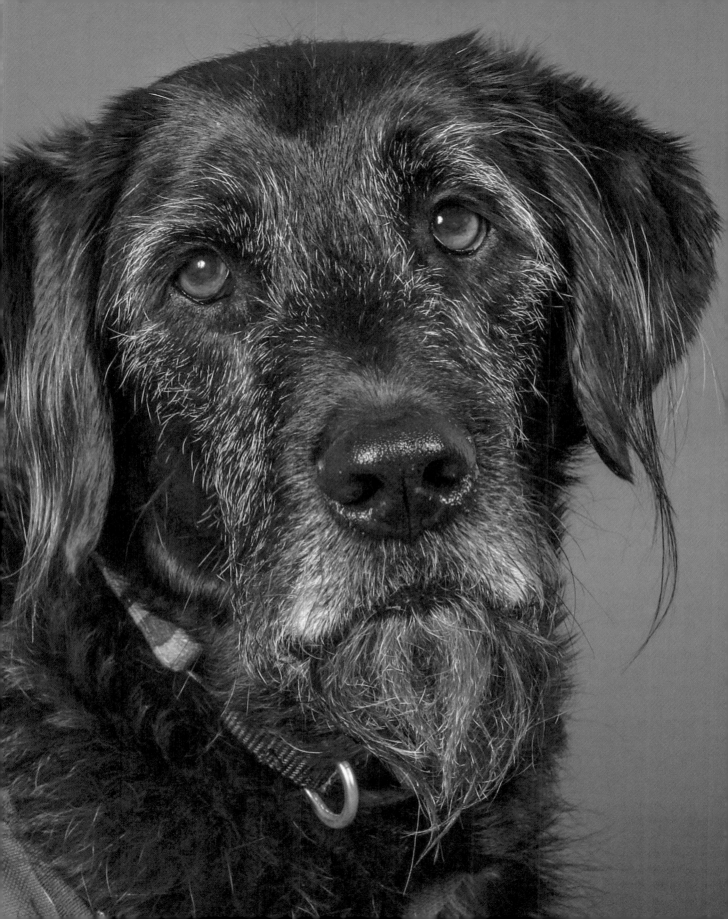

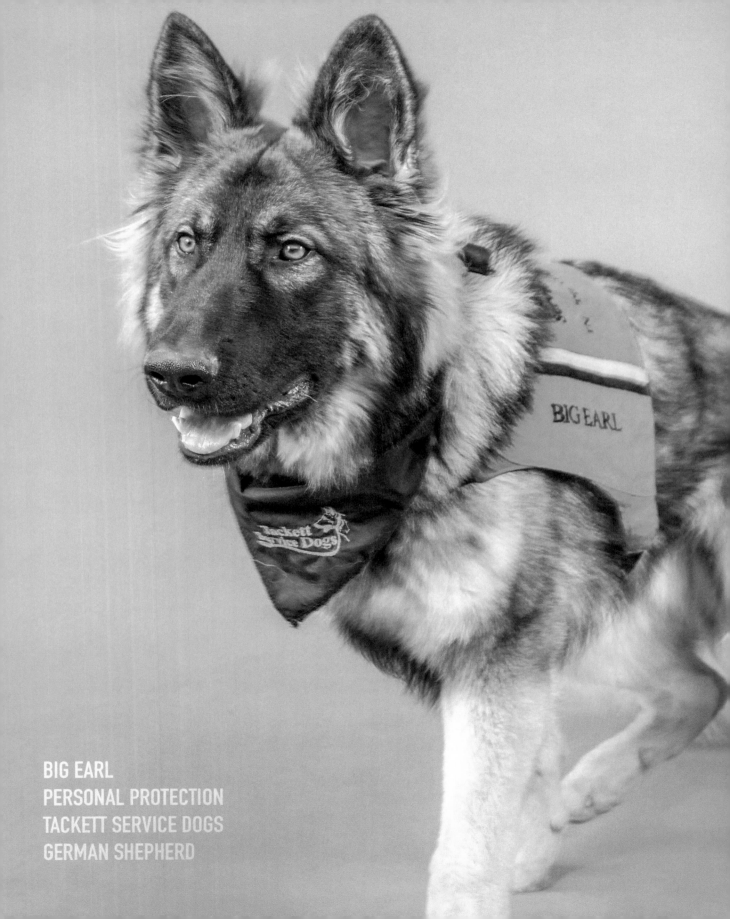

BIG EARL
PERSONAL PROTECTION
TACKETT SERVICE DOGS
GERMAN SHEPHERD

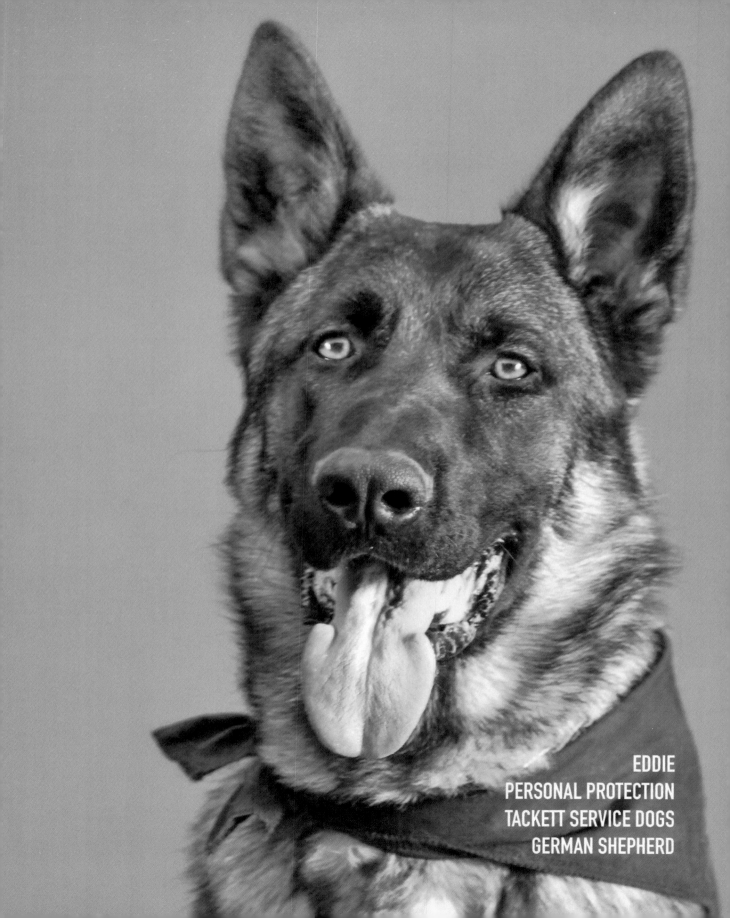

EDDIE
PERSONAL PROTECTION
TACKETT SERVICE DOGS
GERMAN SHEPHERD

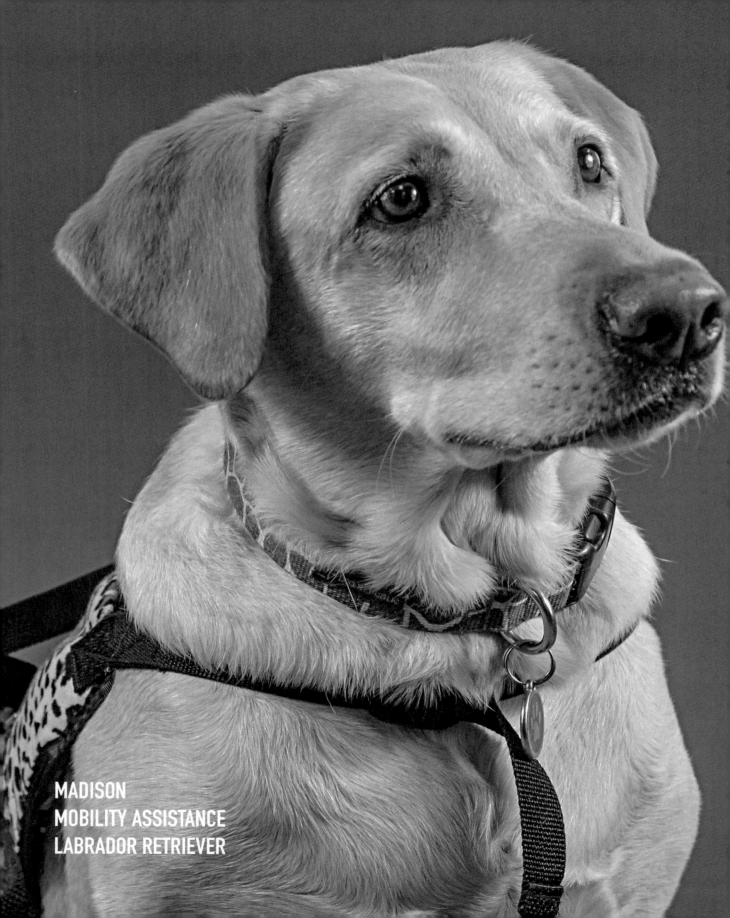

MADISON
MOBILITY ASSISTANCE
LABRADOR RETRIEVER

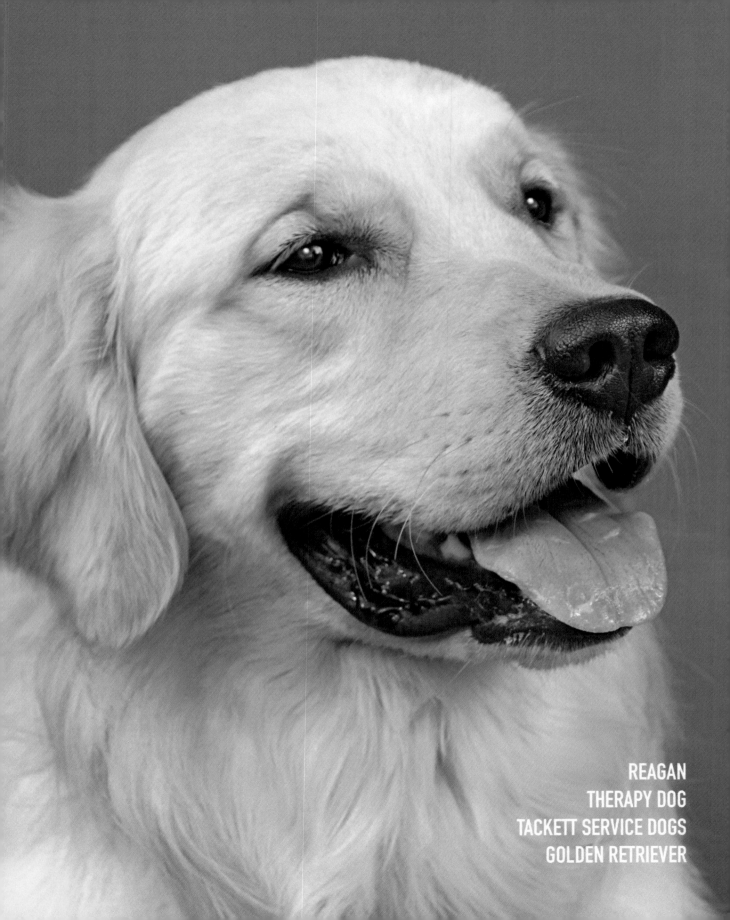

REAGAN
THERAPY DOG
TACKETT SERVICE DOGS
GOLDEN RETRIEVER

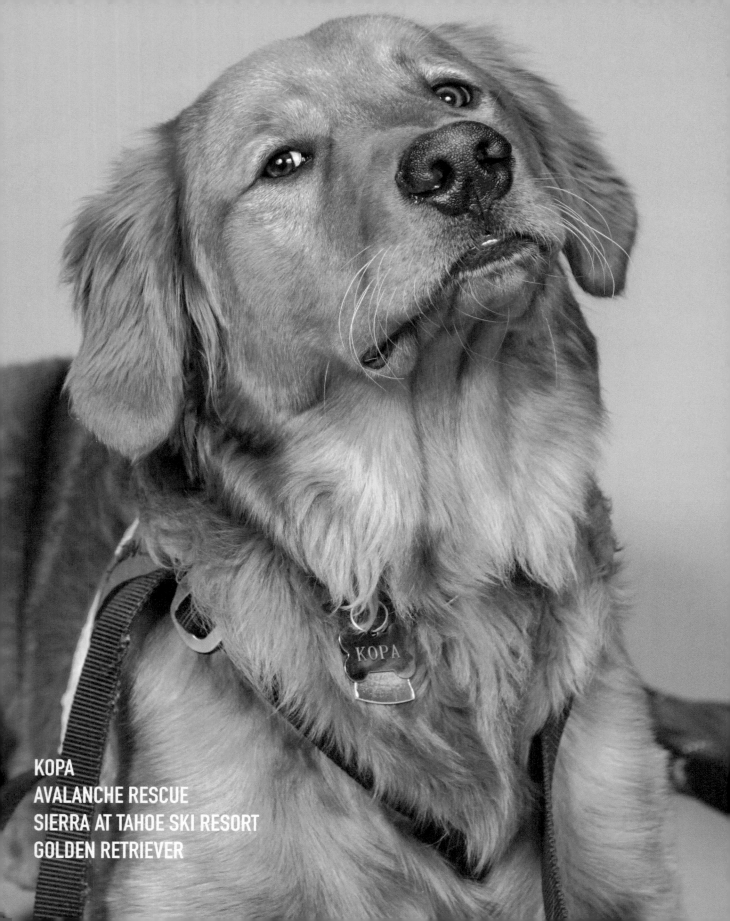

KOPA
AVALANCHE RESCUE
SIERRA AT TAHOE SKI RESORT
GOLDEN RETRIEVER

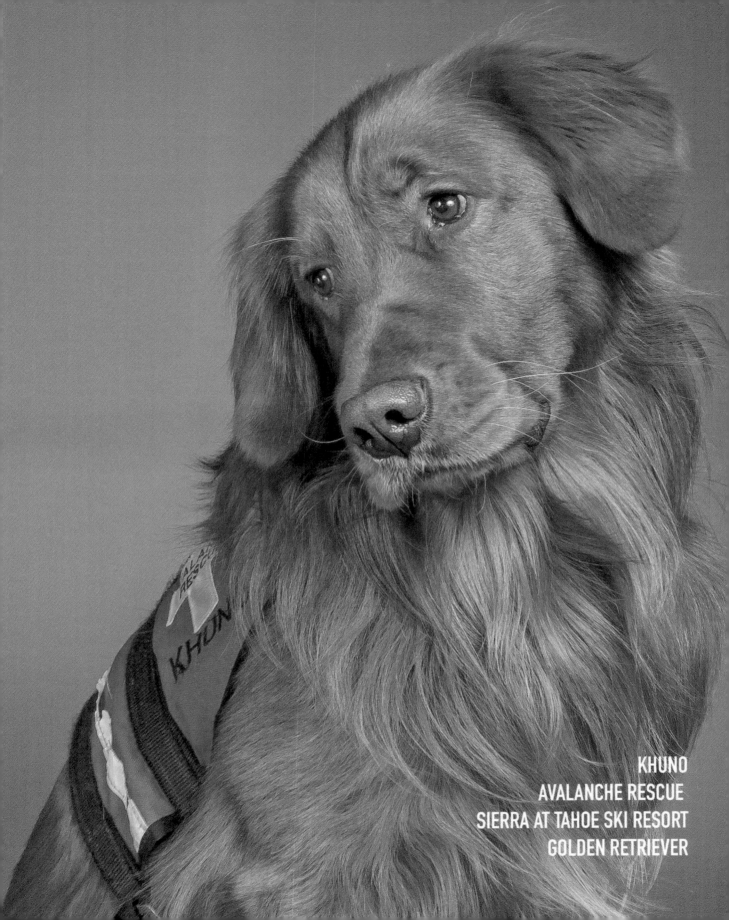

KHUNO
AVALANCHE RESCUE
SIERRA AT TAHOE SKI RESORT
GOLDEN RETRIEVER

When we rescued Gracie, she was one day away from euthanasia. Since then, she's been on over 200 therapy visits to children's hospitals and nursing homes.

- Gracie's Handler

GRACIE
THERAPY DOG
METAMUTTS
MCNAB COLLIE

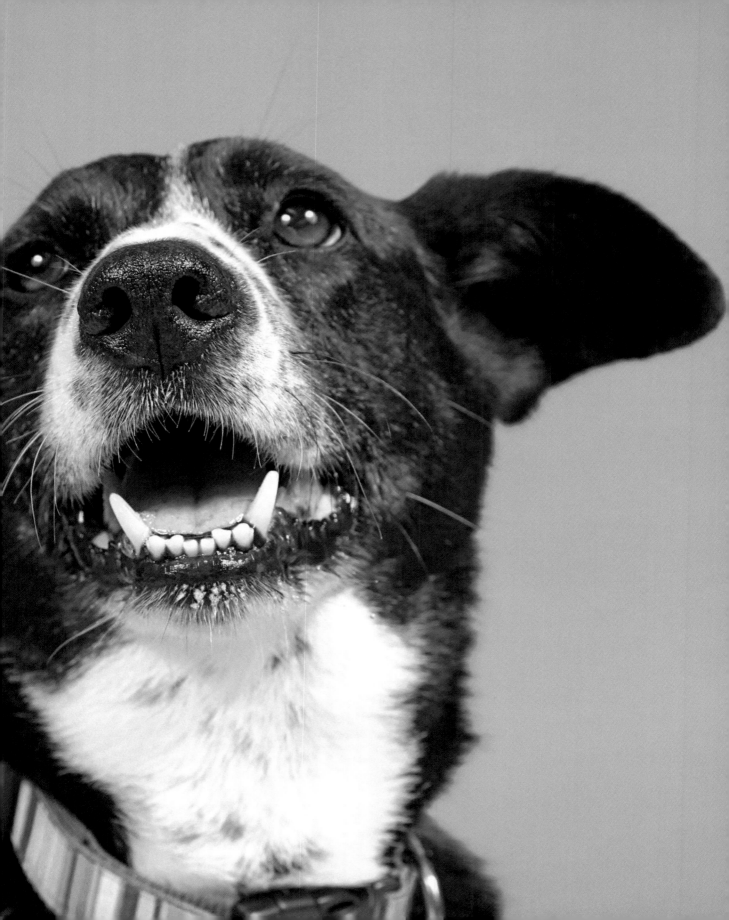

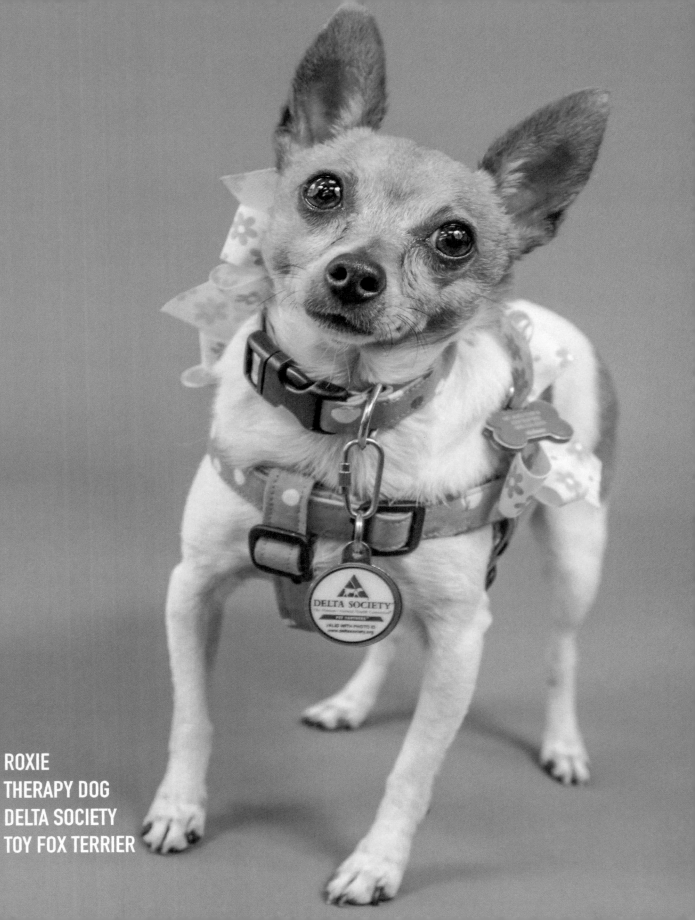

ROXIE
THERAPY DOG
DELTA SOCIETY
TOY FOX TERRIER

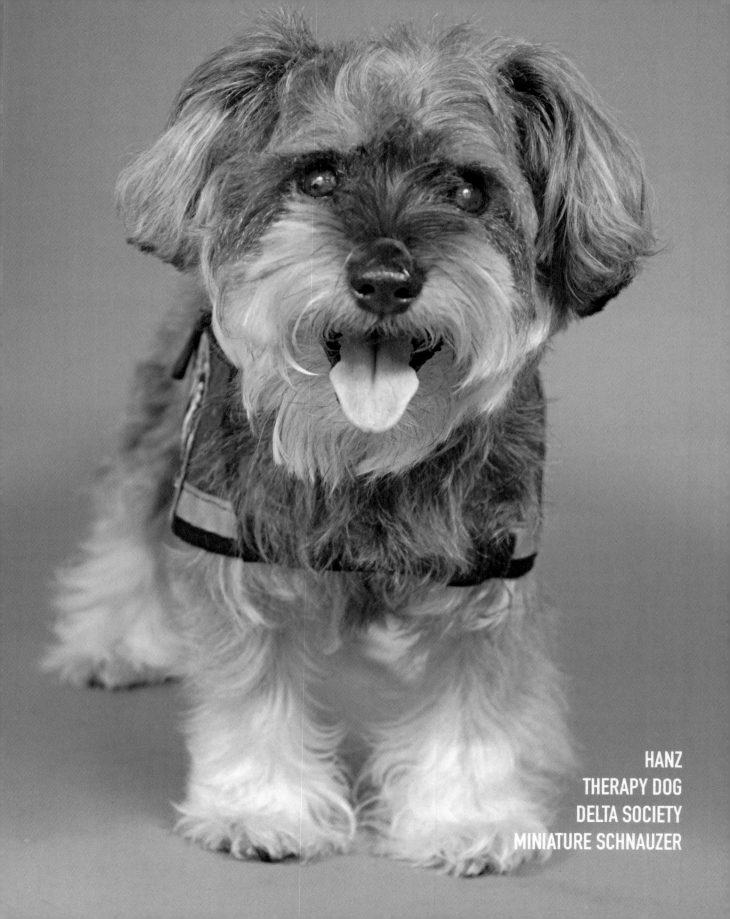

HANZ
THERAPY DOG
DELTA SOCIETY
MINIATURE SCHNAUZER

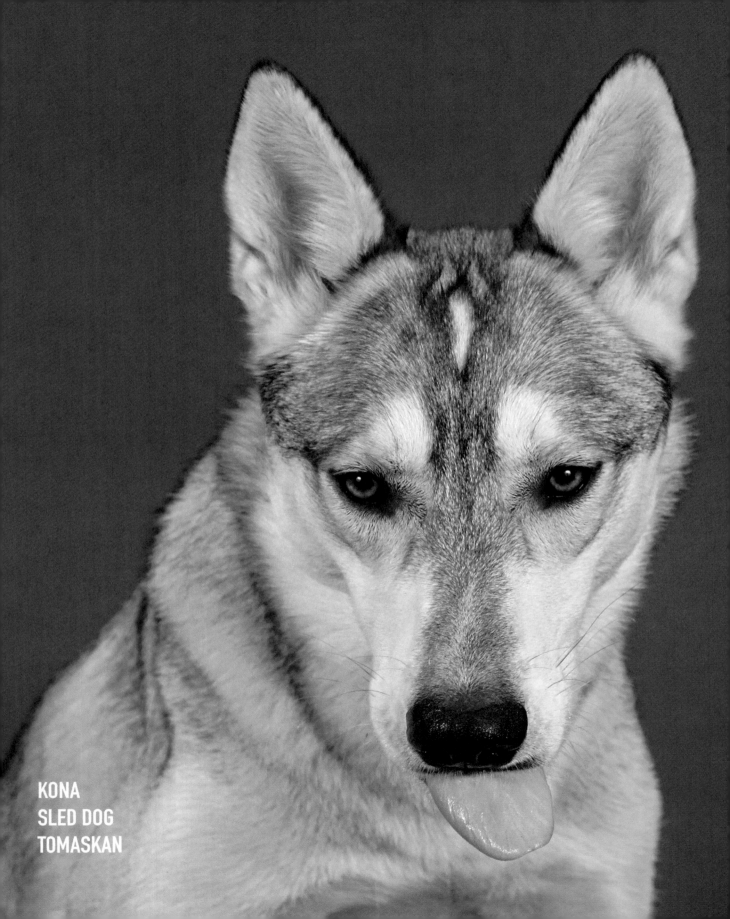

KONA
SLED DOG
TOMASKAN

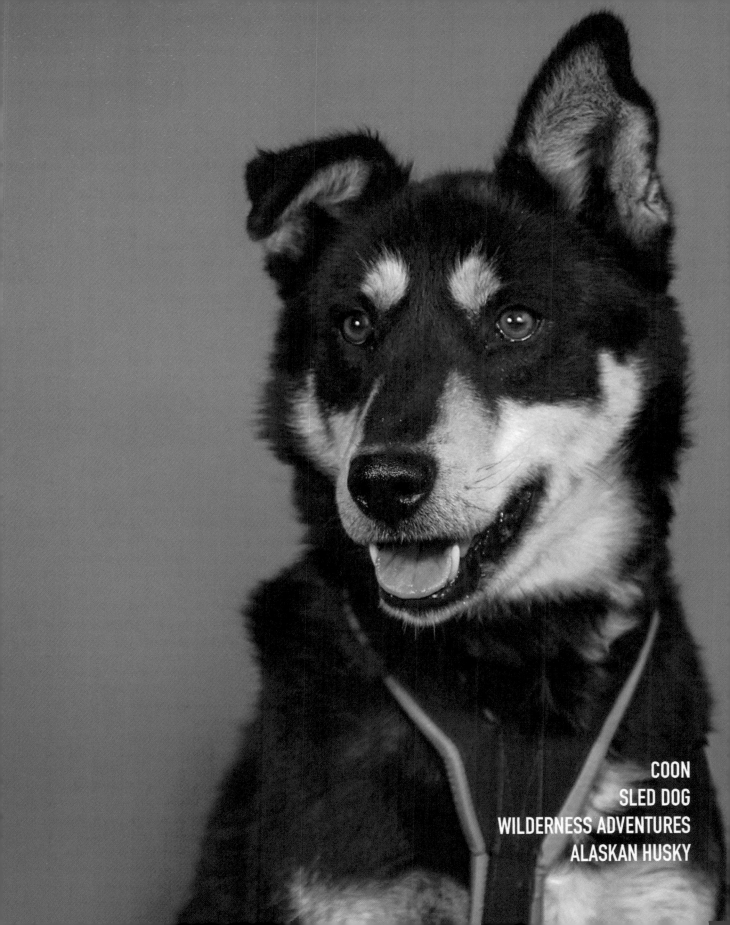

COON
SLED DOG
WILDERNESS ADVENTURES
ALASKAN HUSKY

LEXI
MOBILITY ASSISTANCE & BLOOD DONOR
SIBERIAN HUSKY PITBULL MIX

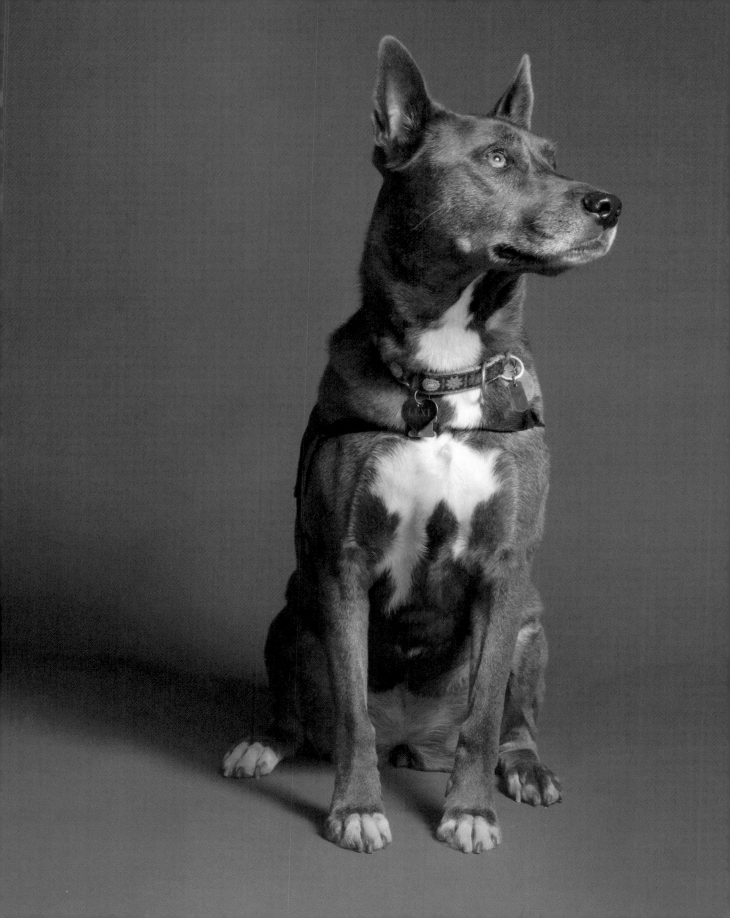

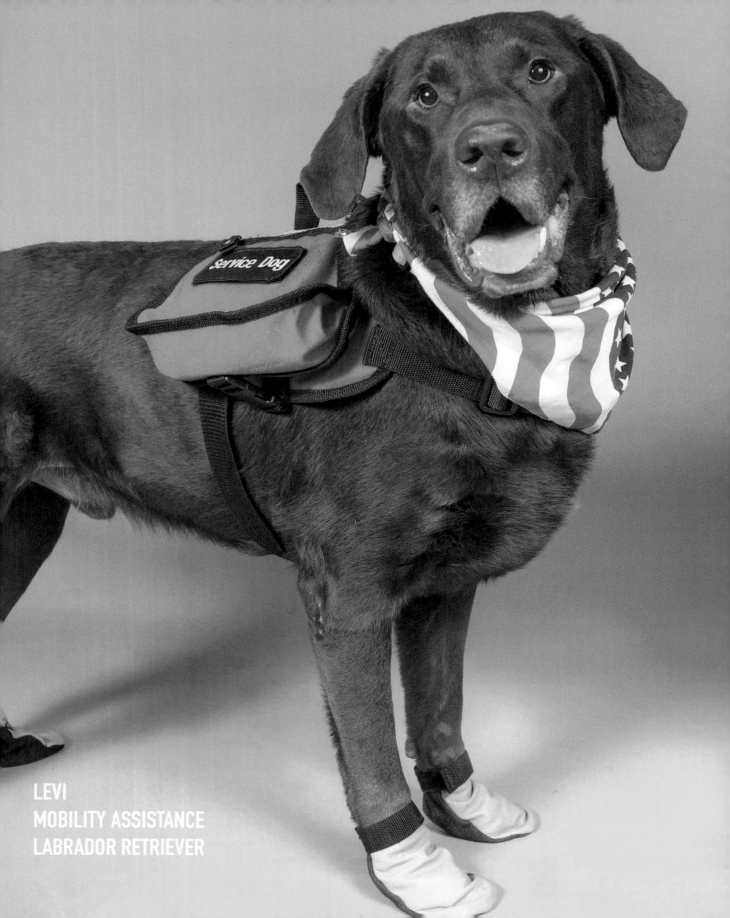

LEVI
MOBILITY ASSISTANCE
LABRADOR RETRIEVER

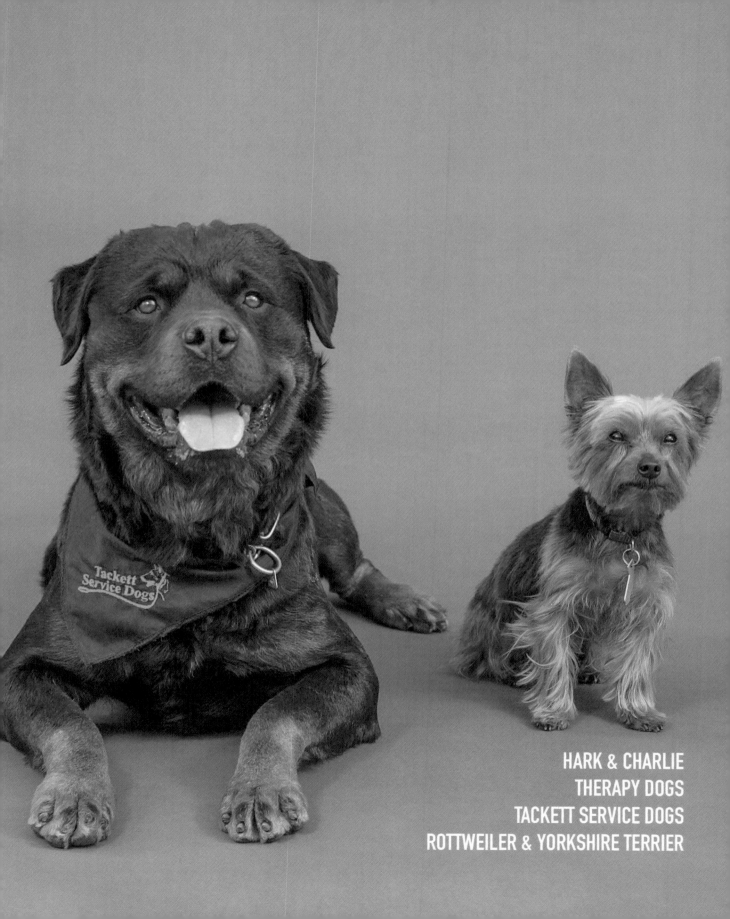

HARK & CHARLIE
THERAPY DOGS
TACKETT SERVICE DOGS
ROTTWEILER & YORKSHIRE TERRIER

Sadie works in the Major Crimes Unit of the Colorado Bureau of Investigation. She has worked over 400 fires, has never lost a case in court, and has assisted resulting in numerous arrests, including high-profile arson/homicide cases where her nose has detected critical evidence for collection and prosecution.

- Sadie's Handler

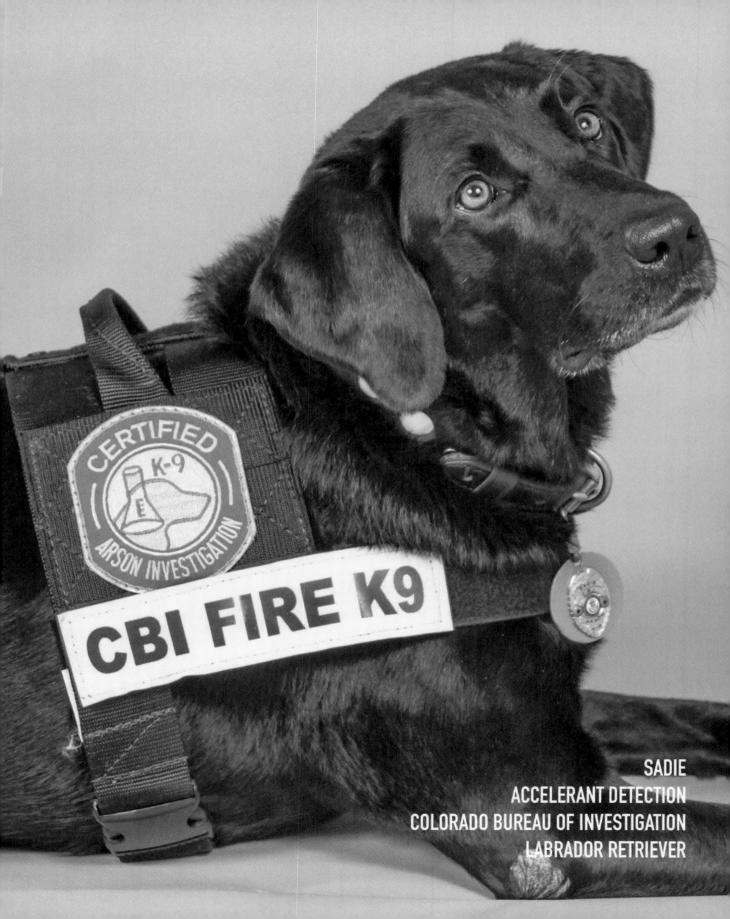

CERTIFIED K-9 E ARSON INVESTIGATION

CBI FIRE K9

SADIE
ACCELERANT DETECTION
COLORADO BUREAU OF INVESTIGATION
LABRADOR RETRIEVER

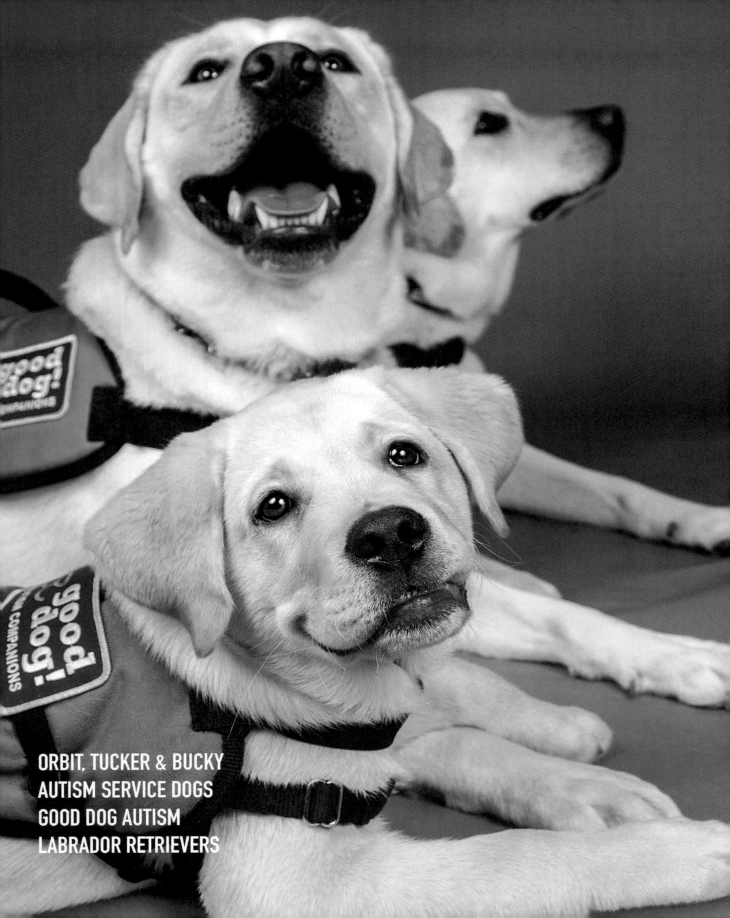

ORBIT, TUCKER & BUCKY
AUTISM SERVICE DOGS
GOOD DOG AUTISM
LABRADOR RETRIEVERS

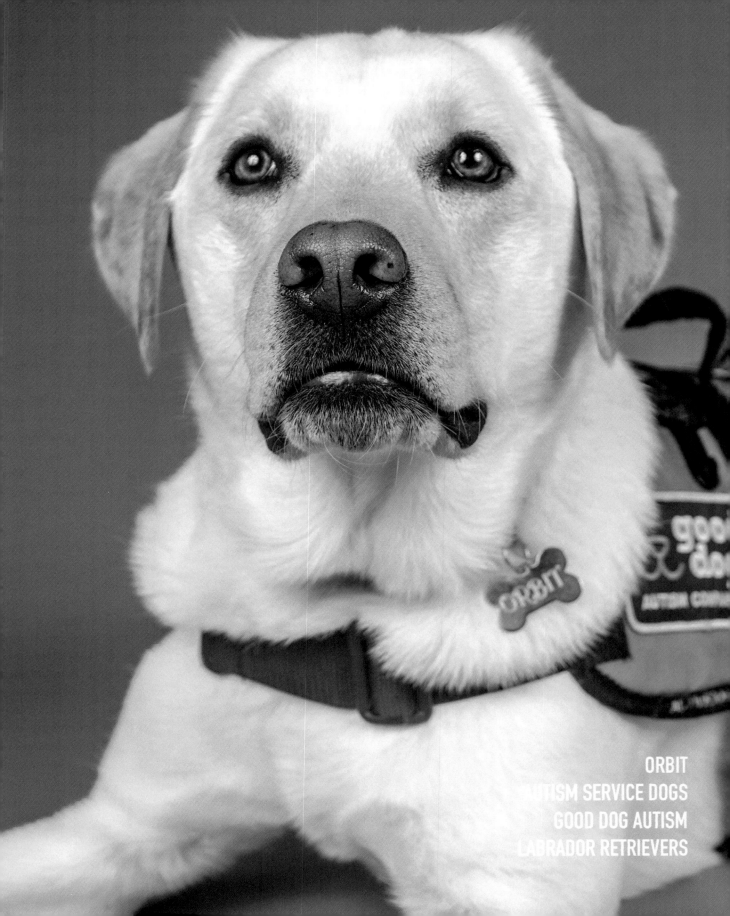

ORBIT
AUTISM SERVICE DOGS
GOOD DOG AUTISM
LABRADOR RETRIEVERS

STEWIE
CANCER DETECTION
IN SITU FOUNDATION
AUSTRALIAN SHEPHERD

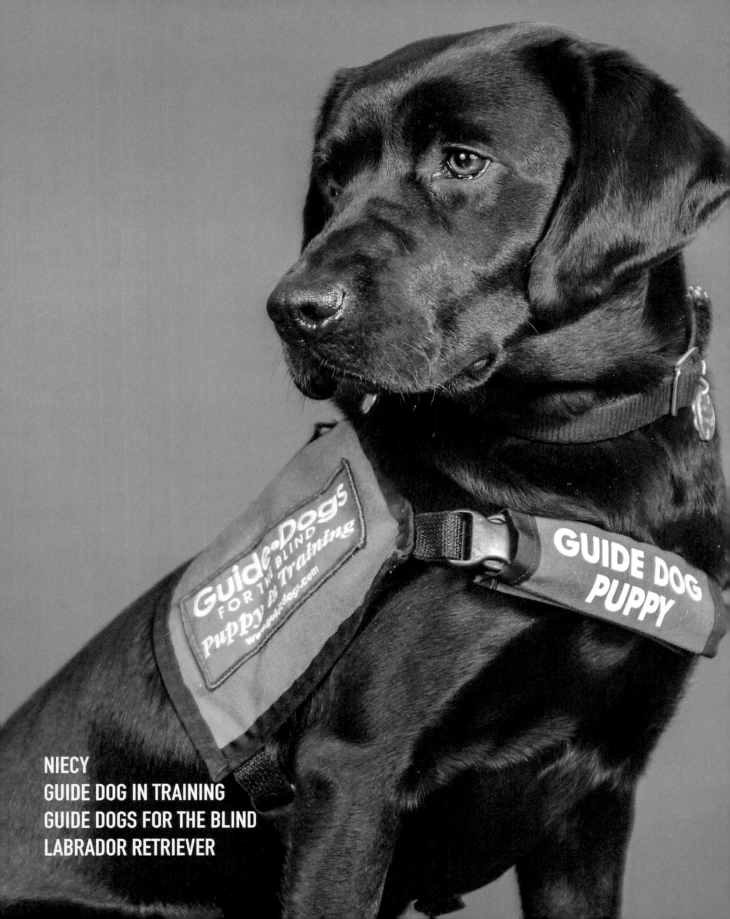

NIECY
GUIDE DOG IN TRAINING
GUIDE DOGS FOR THE BLIND
LABRADOR RETRIEVER

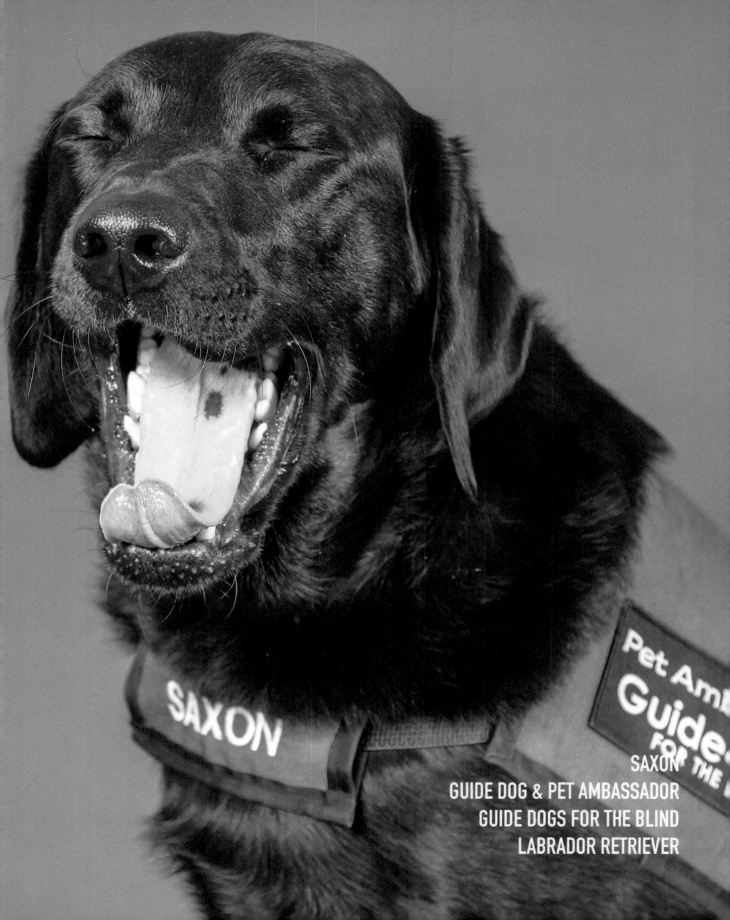

SAXON

Pet Am

Guide

FOR THE B

SAXON

GUIDE DOG & PET AMBASSADOR

GUIDE DOGS FOR THE BLIND

LABRADOR RETRIEVER

It amazes me how effortlessly we glide around obstacles and through the world. And what's more is his ability to find the important things I need as I get around. Things like taking me to the right buttons for an elevator, getting me adjacent to stair railings or picking out an open chair in a crowded doctor's office. While he's technically 'just a dog', Zorro is so much more - he gives me independence, freedom, and care that not even the best qualified human could provide. He's not just a dog, he's family.

- Zorro's Handler

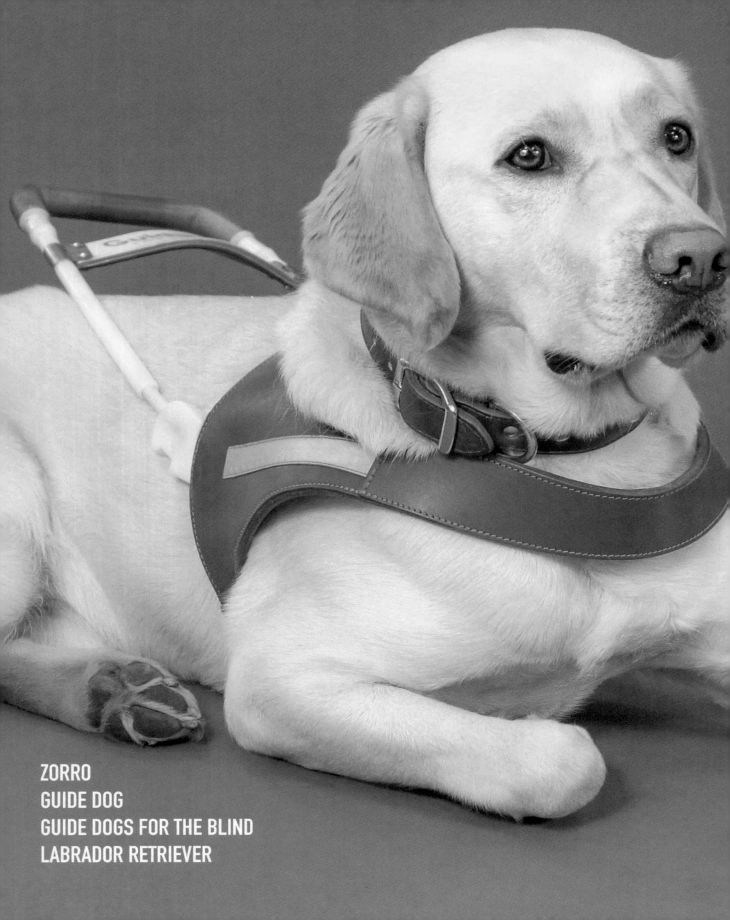

ZORRO
GUIDE DOG
GUIDE DOGS FOR THE BLIND
LABRADOR RETRIEVER

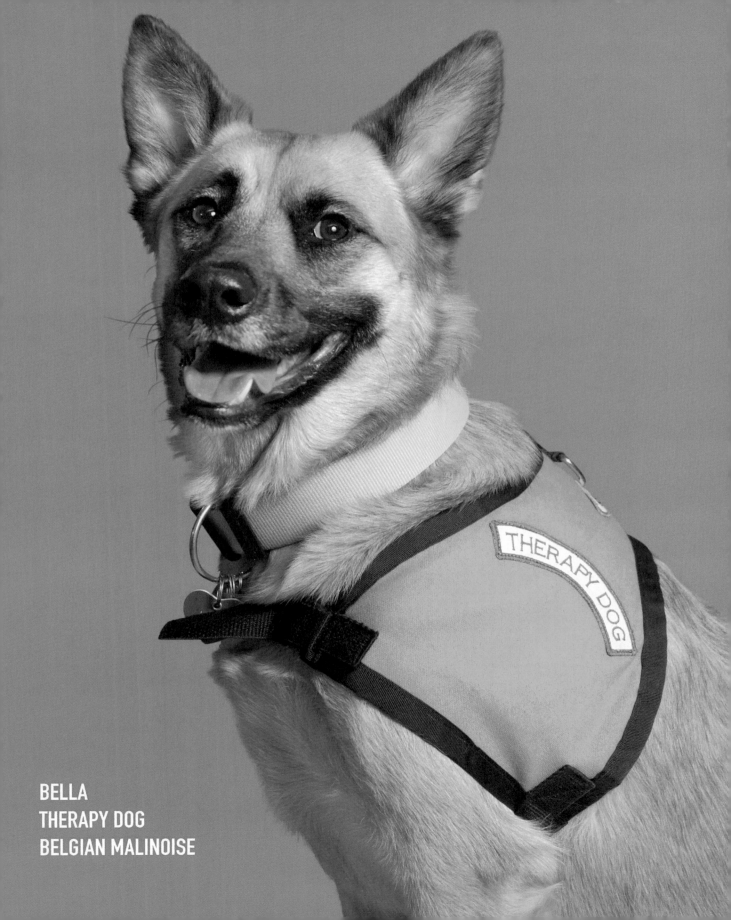

BELLA
THERAPY DOG
BELGIAN MALINOISE

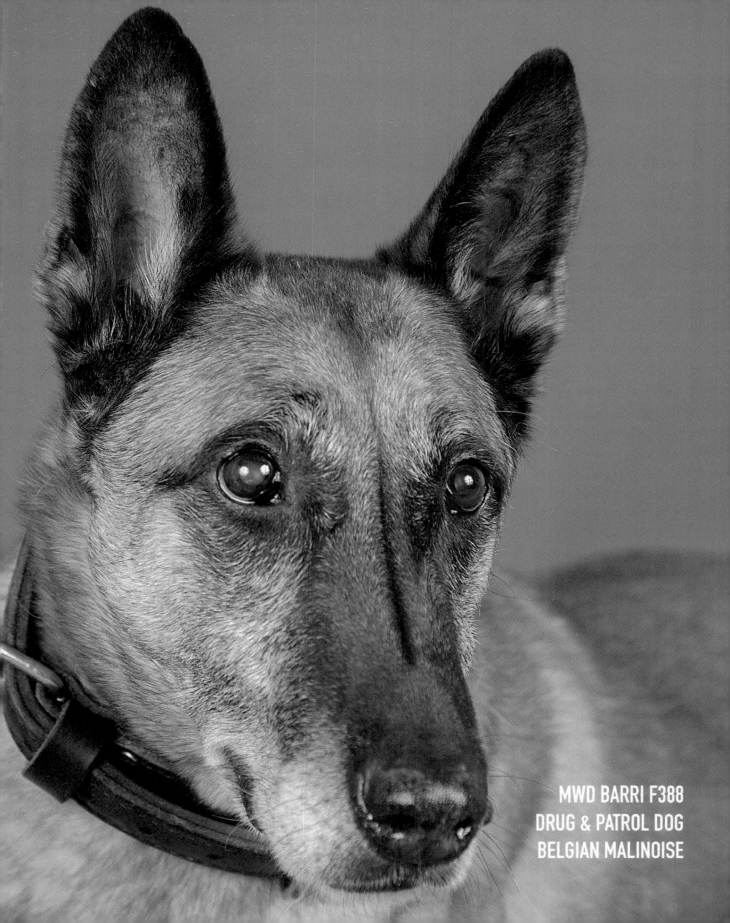

MWD BARRI F388
DRUG & PATROL DOG
BELGIAN MALINOISE

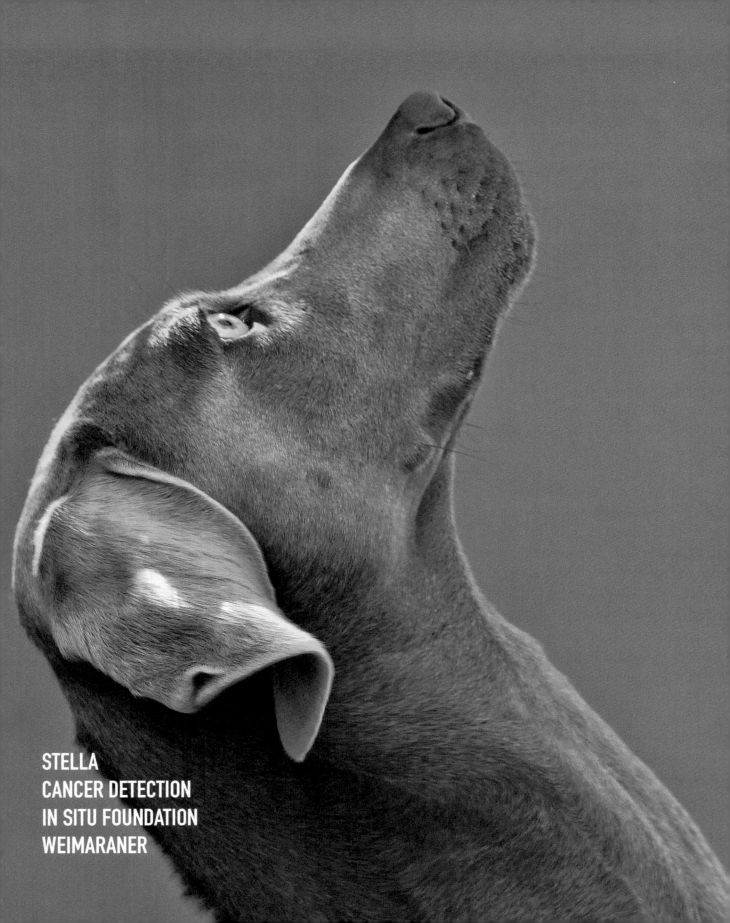

STELLA
CANCER DETECTION
IN SITU FOUNDATION
WEIMARANER

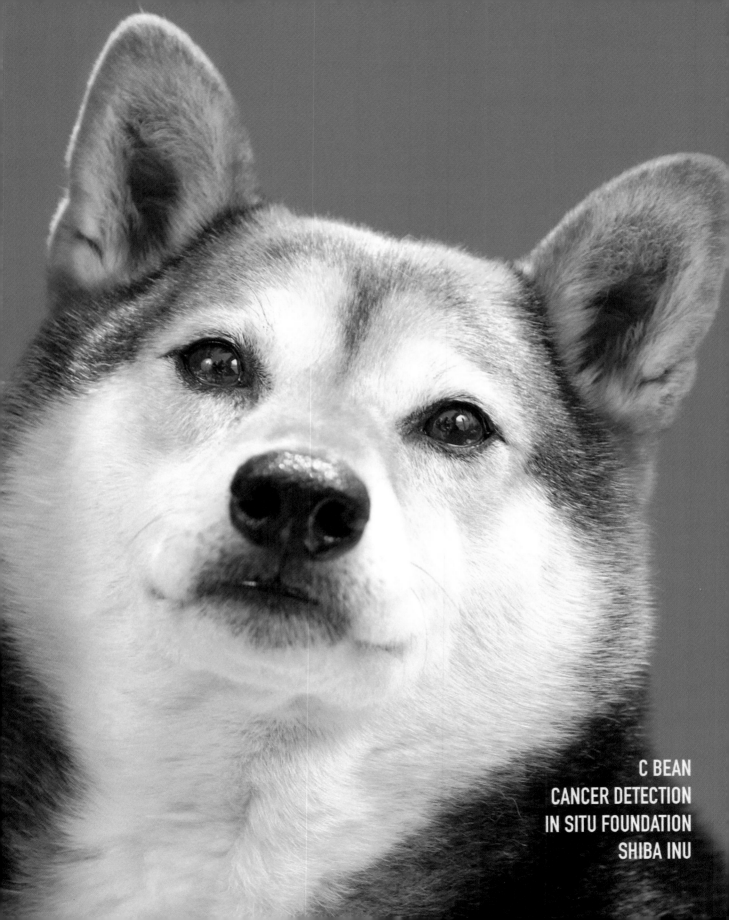

C BEAN
CANCER DETECTION
IN SITU FOUNDATION
SHIBA INU

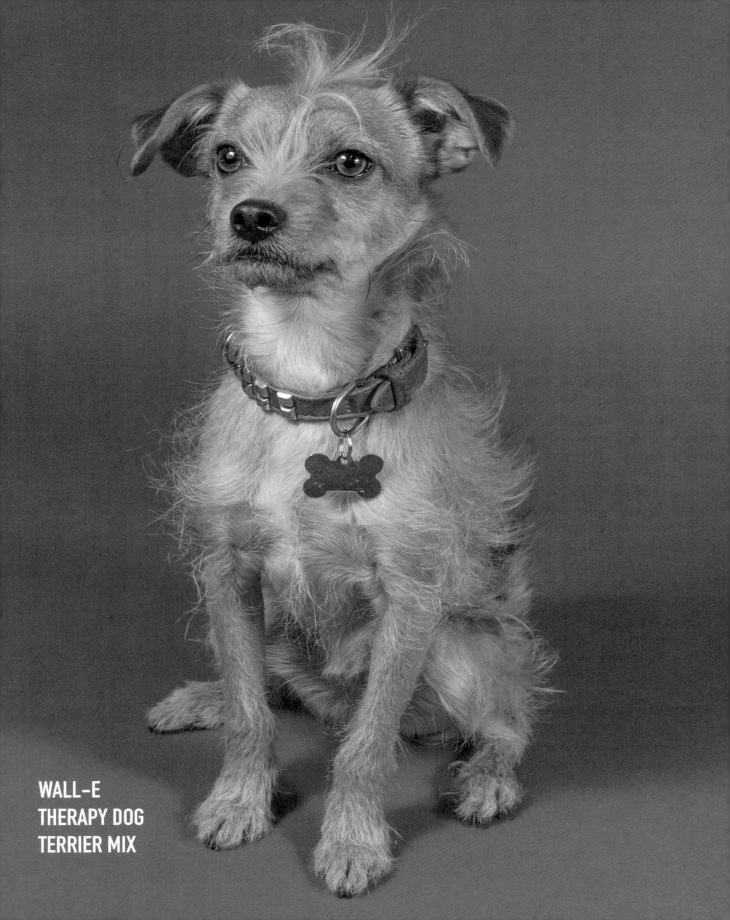

WALL-E
THERAPY DOG
TERRIER MIX

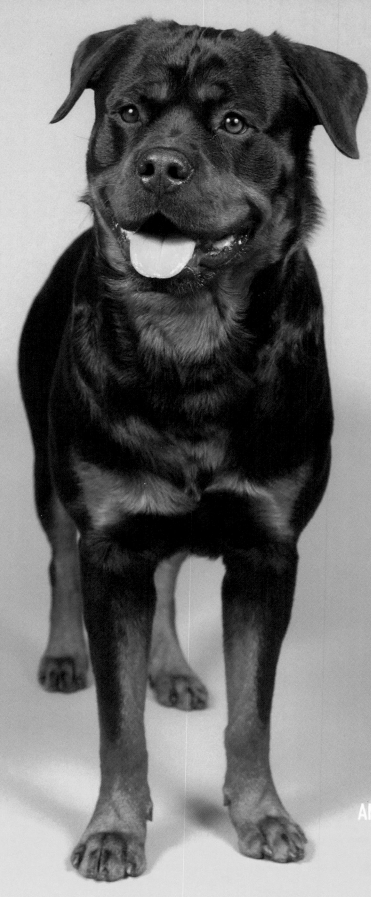

WINSTON
THERAPY DOG
AMERICAN CANINE TRAINING
ROTTWEILER

A lot of people aren't used to seeing a Mastiff as a service dog. I get stopped all the time. She's helped me more than any doctor, therapist or medication has ever been able to, so I really like sharing her with others since she's done so much for me and brought me so much happiness.

- Nina's Handler

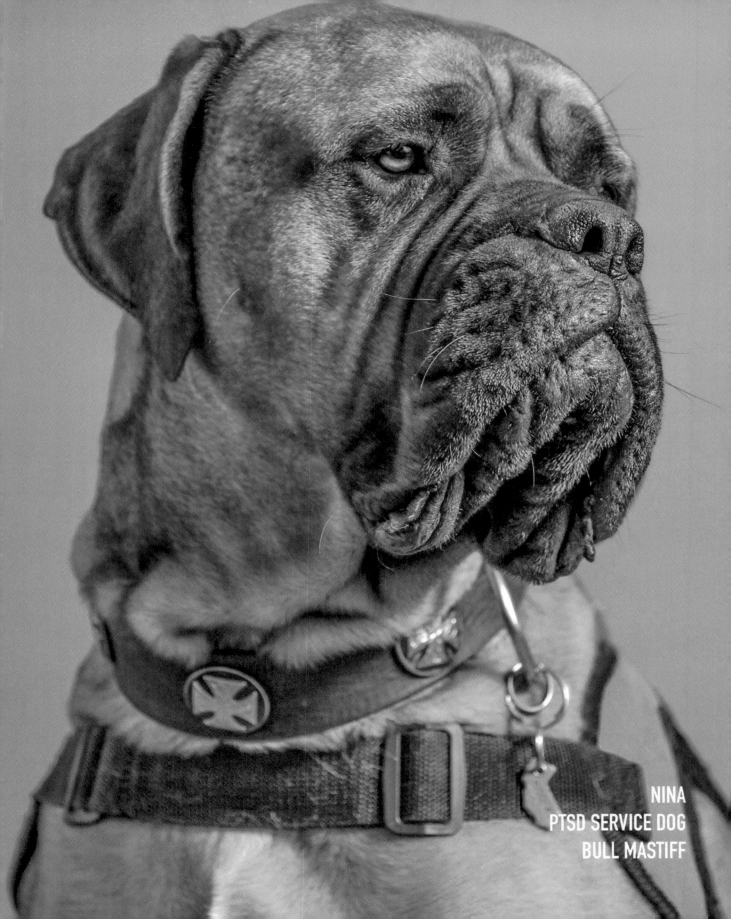

NINA
PTSD SERVICE DOG
BULL MASTIFF

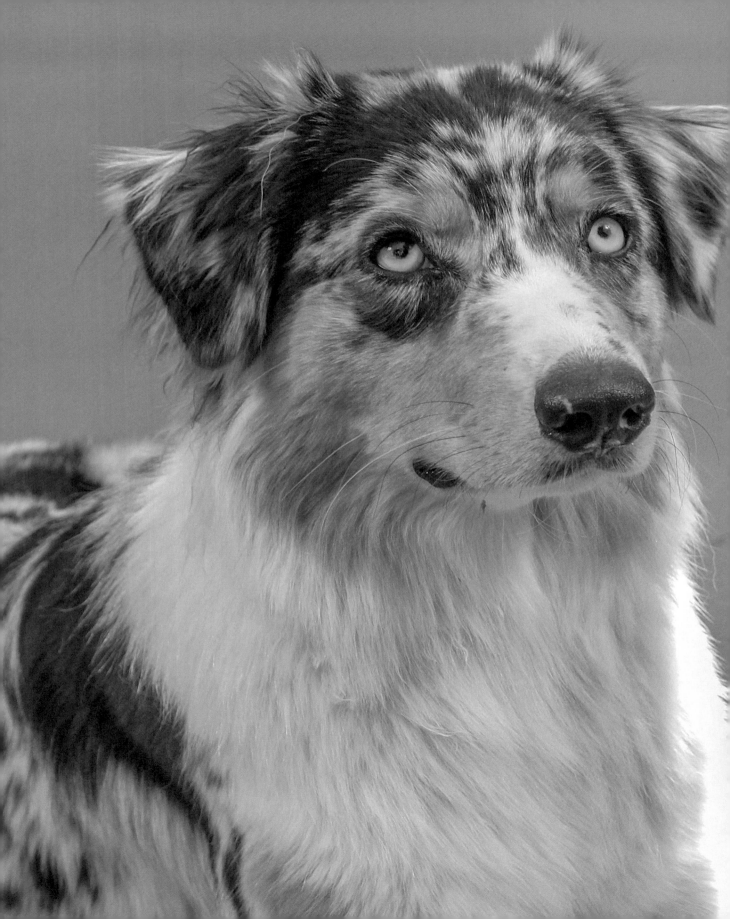

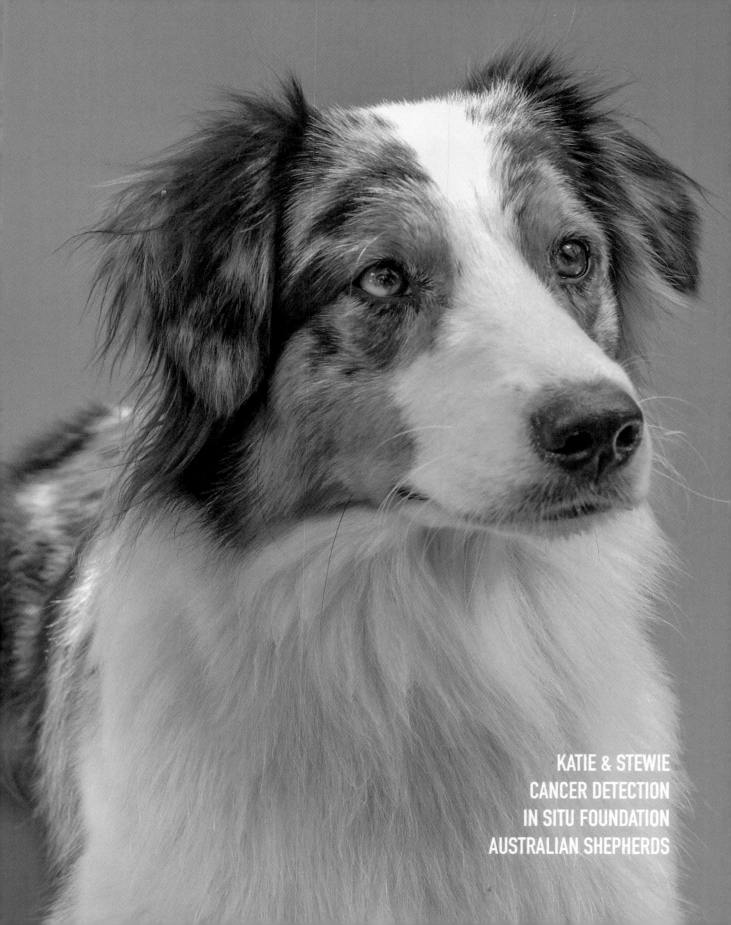

KATIE & STEWIE
CANCER DETECTION
IN SITU FOUNDATION
AUSTRALIAN SHEPHERDS

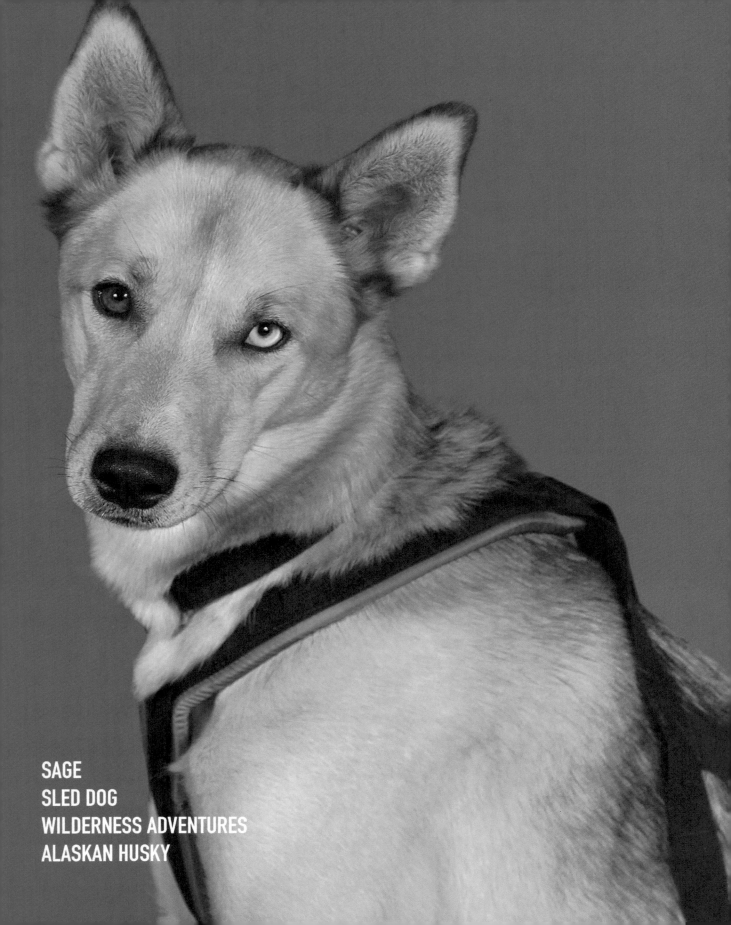

SAGE
SLED DOG
WILDERNESS ADVENTURES
ALASKAN HUSKY

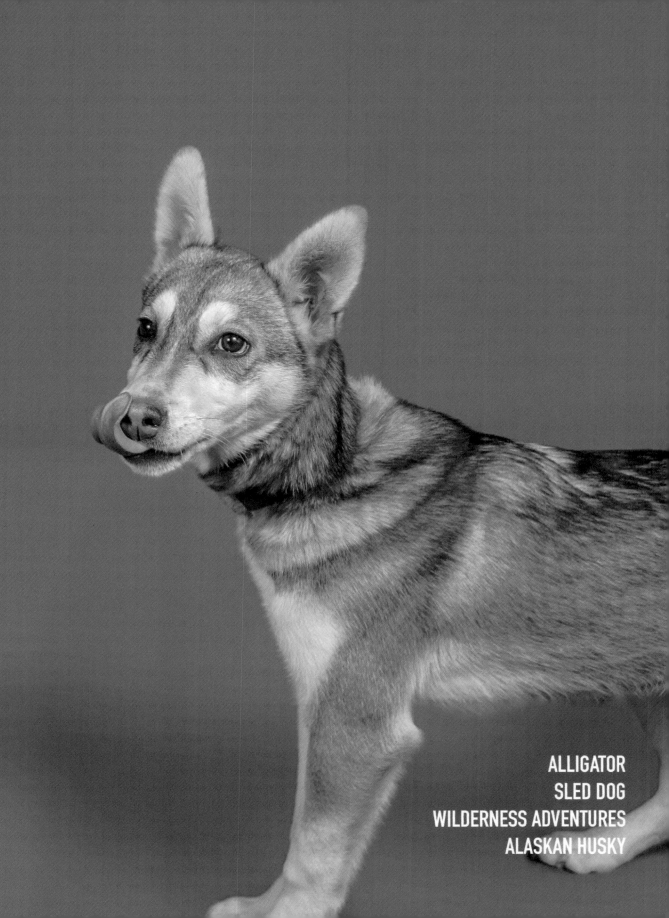

ALLIGATOR
SLED DOG
WILDERNESS ADVENTURES
ALASKAN HUSKY

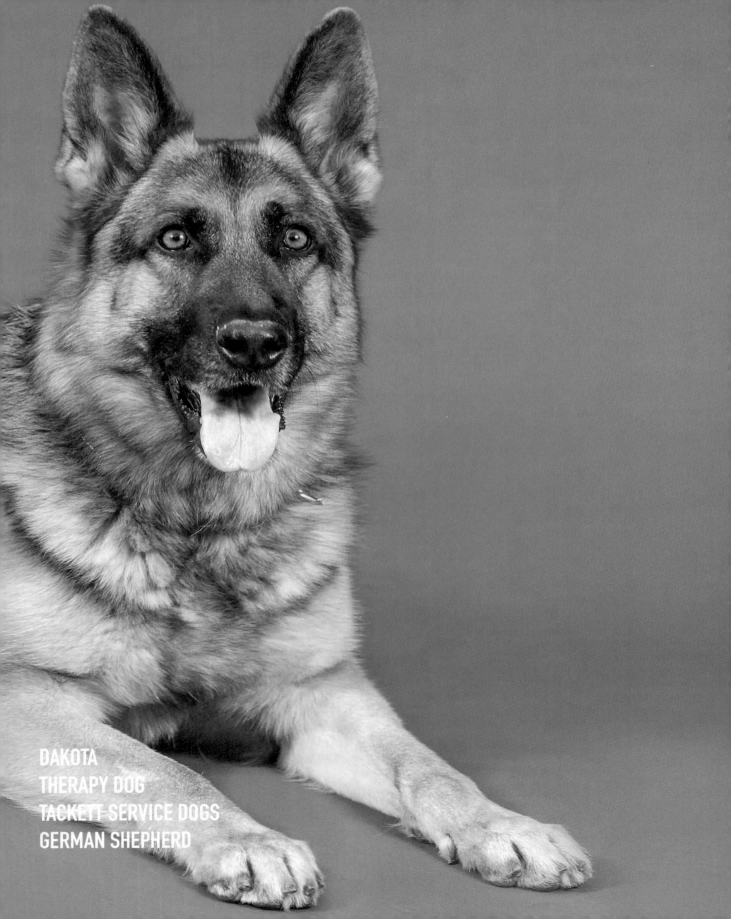

DAKOTA
THERAPY DOG
TACKETT SERVICE DOGS
GERMAN SHEPHERD

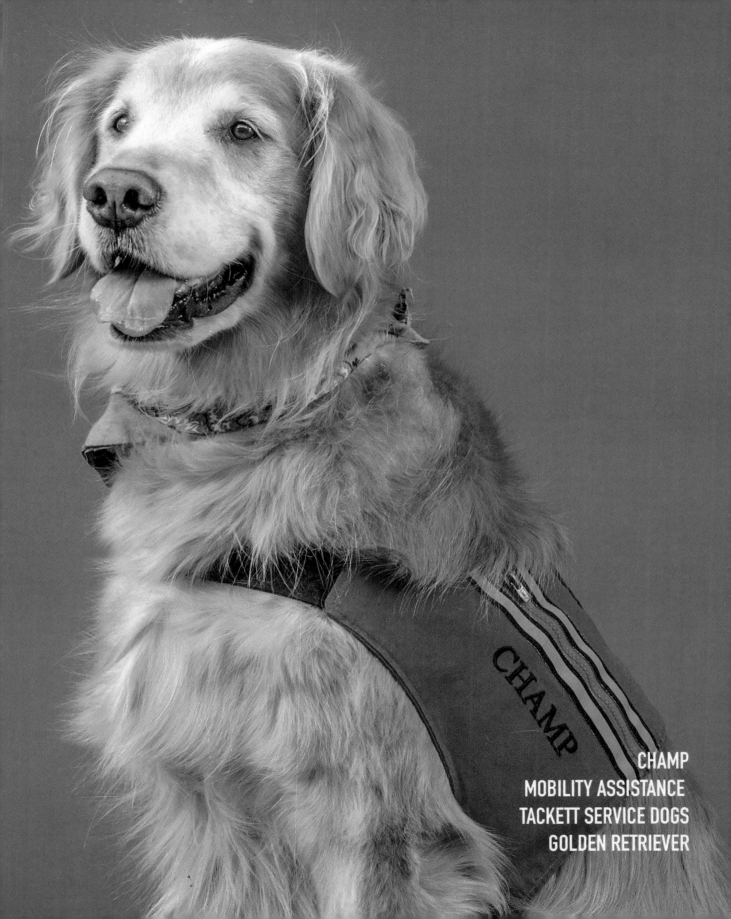

CHAMP
MOBILITY ASSISTANCE
TACKETT SERVICE DOGS
GOLDEN RETRIEVER

BUCKY
AUTISM SERVICE DOG IN TRAINING
GOOD DOG AUTISM
LABRADOR RETRIEVER

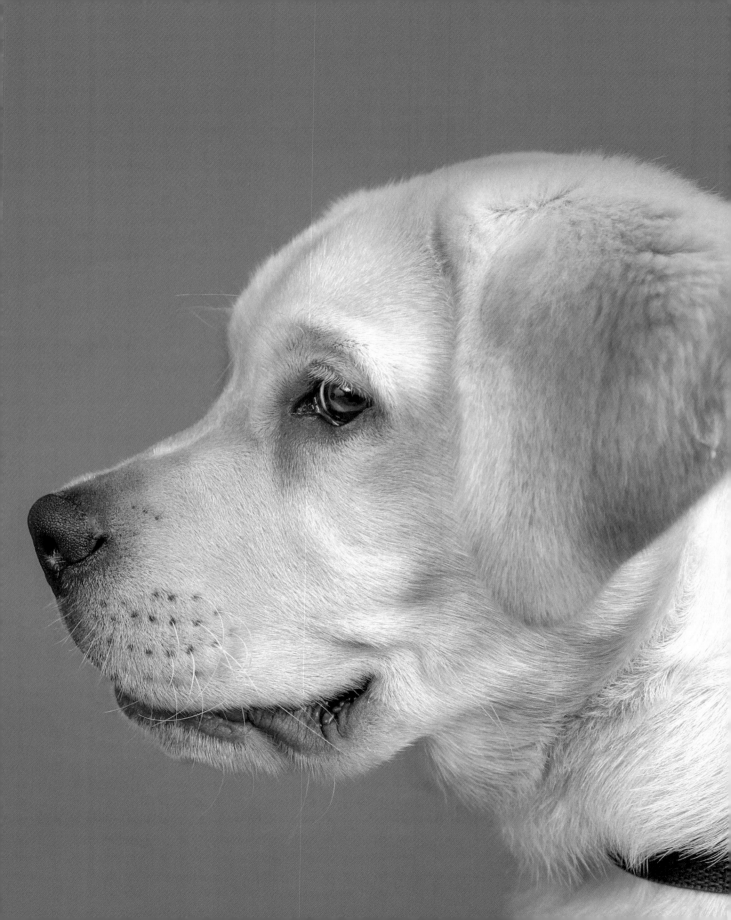

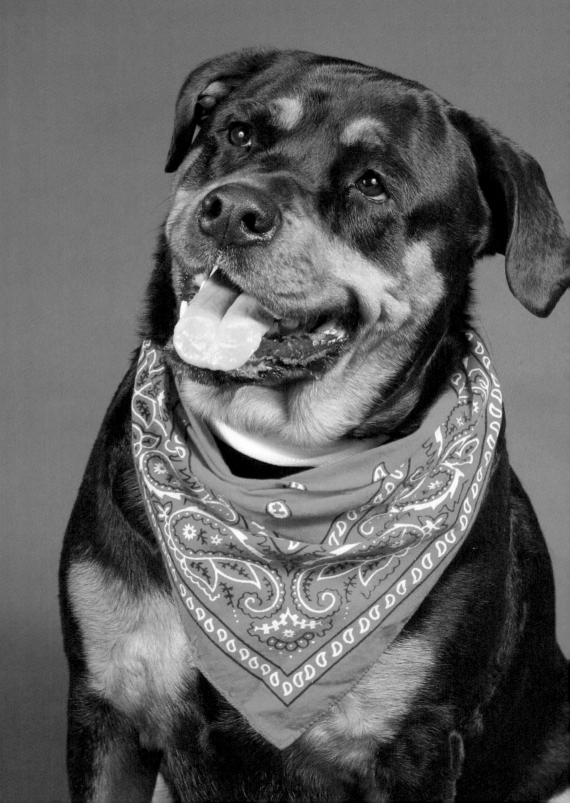

MANDY
BLOOD DONOR
UC DAVIS
ROTTWEILER

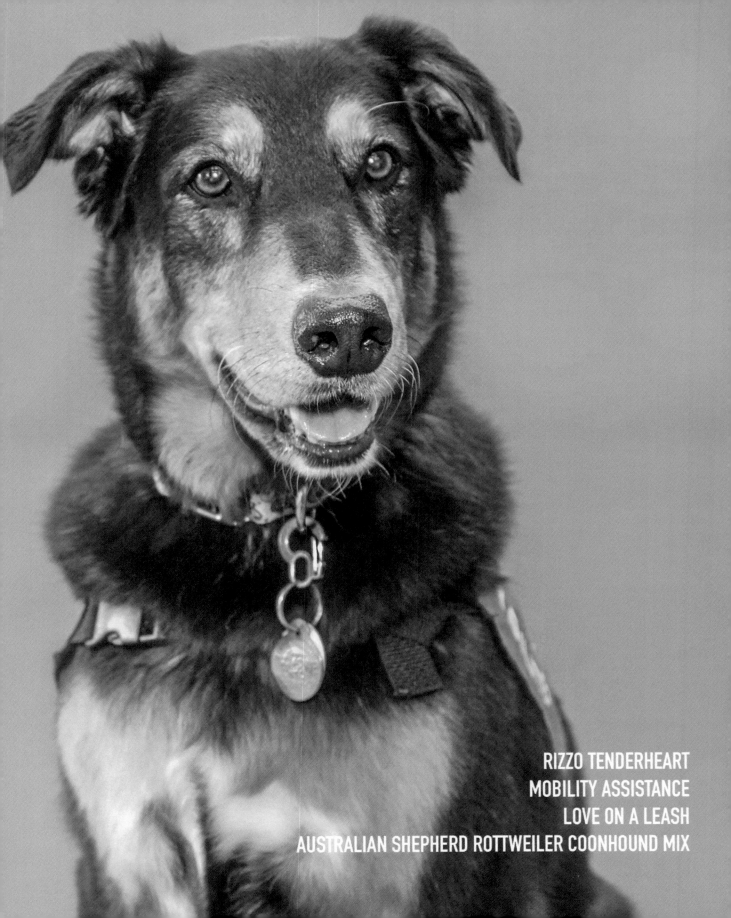

RIZZO TENDERHEART
MOBILITY ASSISTANCE
LOVE ON A LEASH
AUSTRALIAN SHEPHERD ROTTWEILER COONHOUND MIX

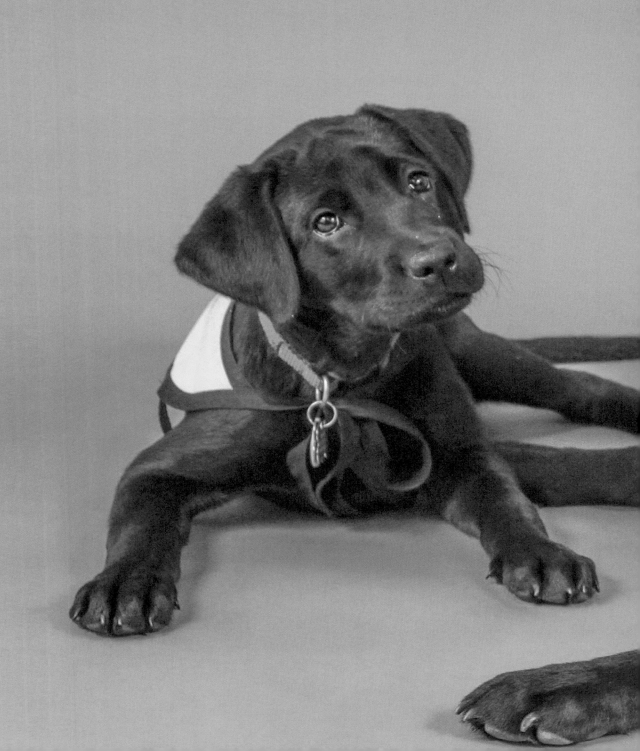

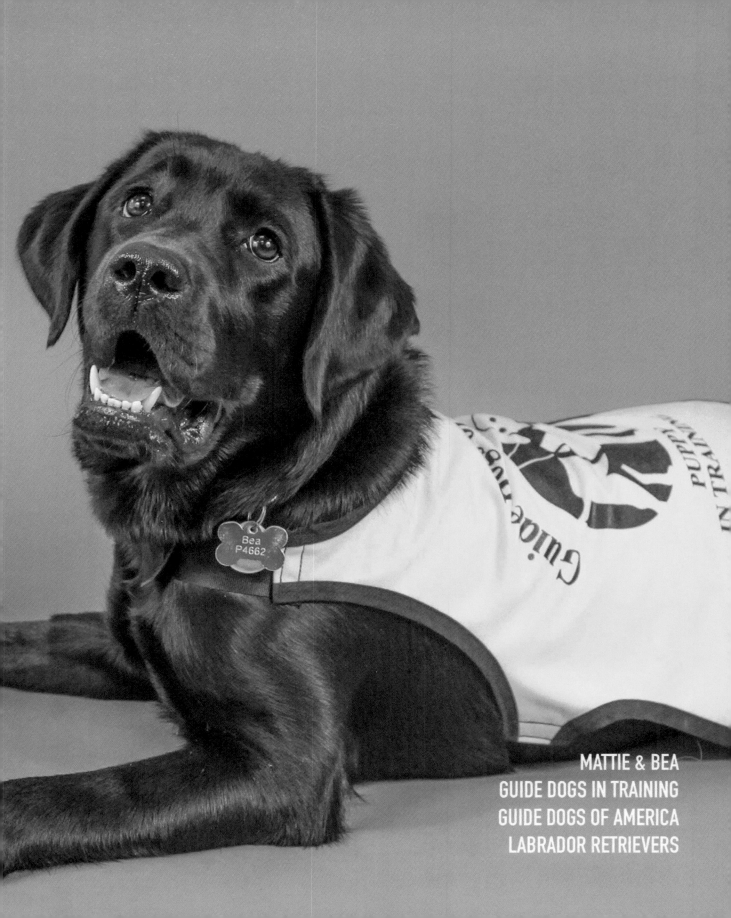

MATTIE & BEA
GUIDE DOGS IN TRAINING
GUIDE DOGS OF AMERICA
LABRADOR RETRIEVERS

It takes over 300 samples to train one cancer detection dog. All of our dogs are trained on cancer samples, healthy control samples, and disease control samples. It takes anywhere between 6 to 8 months to train and certify a dog, our dogs were proven at 99% sensitivity in the early detection of lung cancer and 88% sensitive in the early detection of breast cancer. This is more accurate than a needle biopsy.

- In Situ Foundation

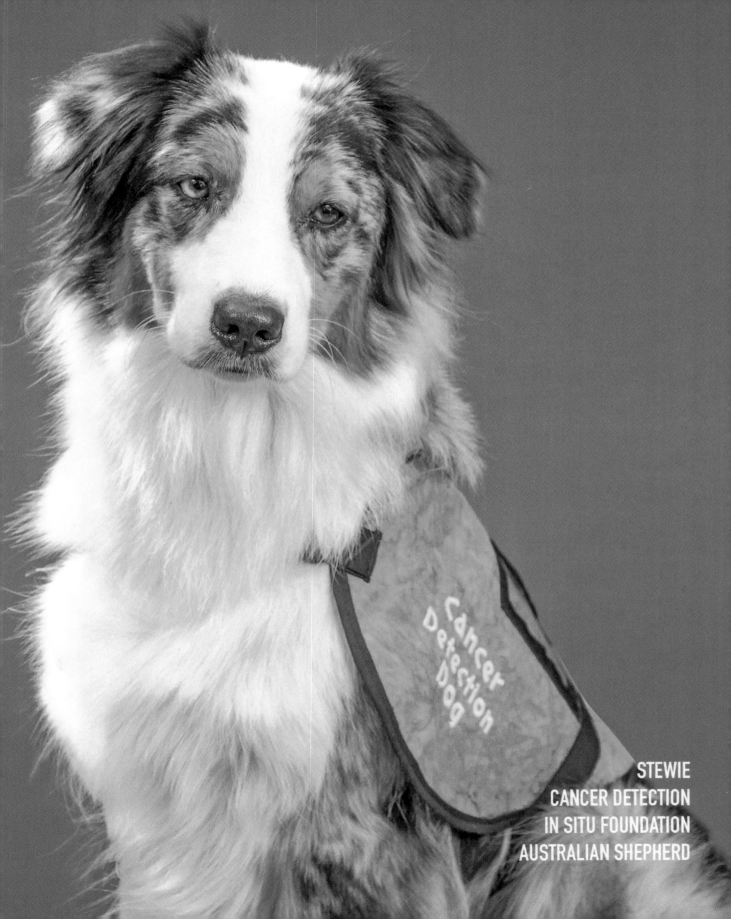

STEWIE
CANCER DETECTION
IN SITU FOUNDATION
AUSTRALIAN SHEPHERD

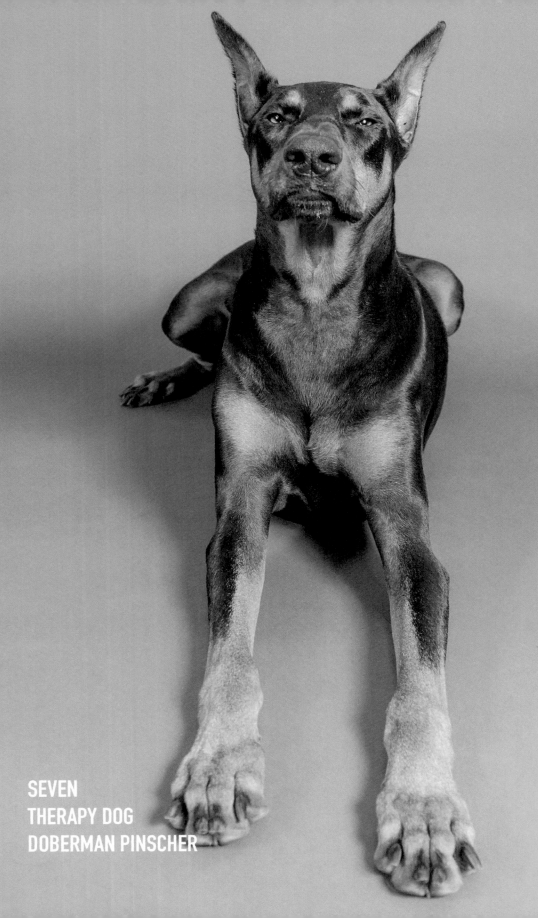

SEVEN
THERAPY DOG
DOBERMAN PINSCHER

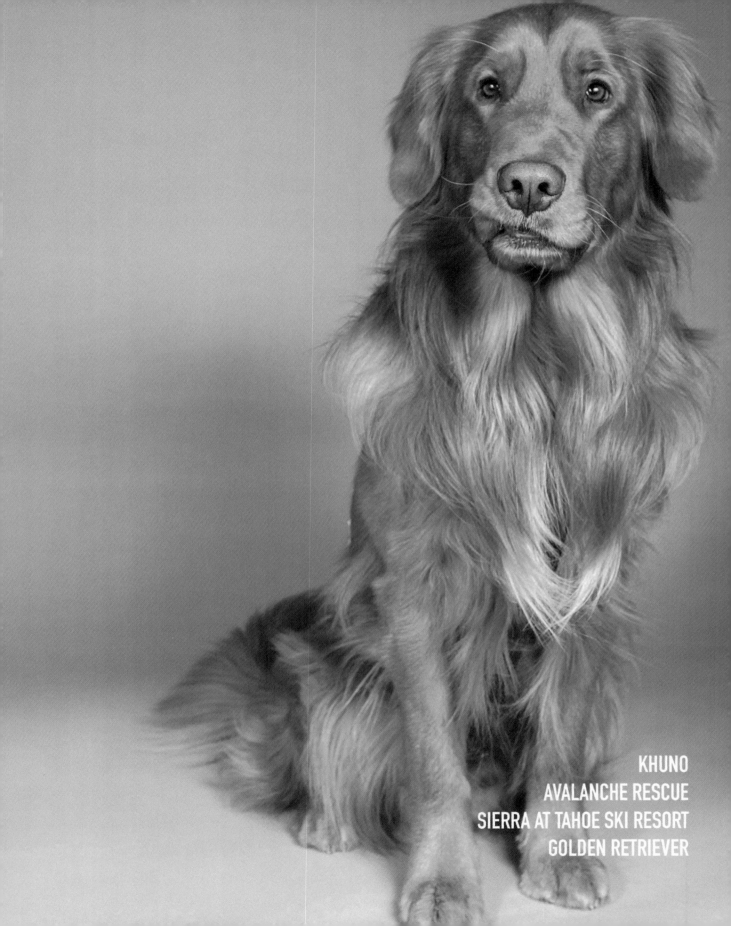

KHUNO
AVALANCHE RESCUE
SIERRA AT TAHOE SKI RESORT
GOLDEN RETRIEVER

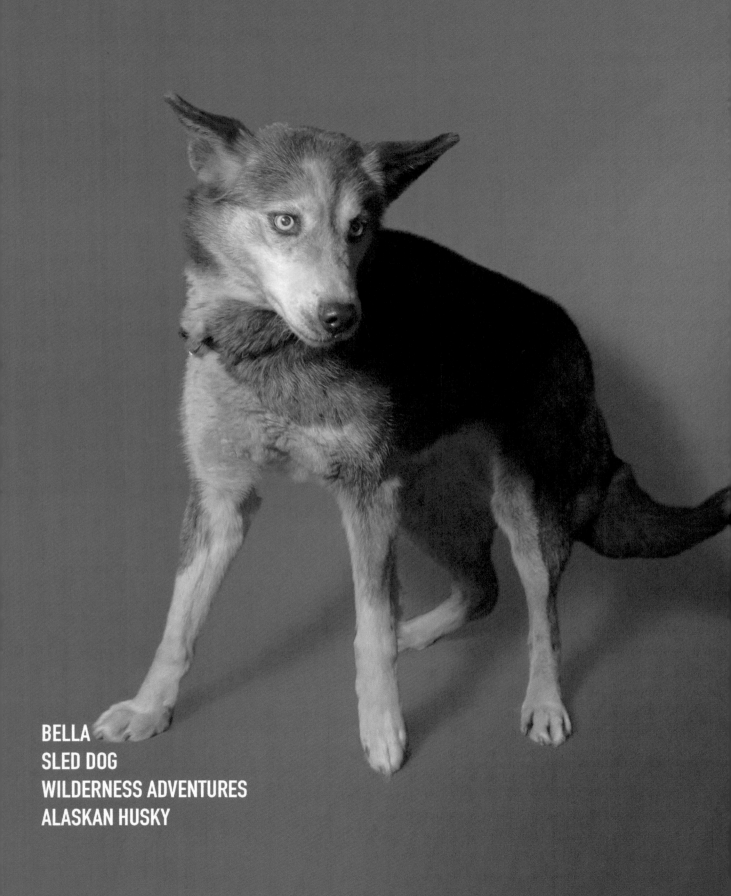

BELLA
SLED DOG
WILDERNESS ADVENTURES
ALASKAN HUSKY

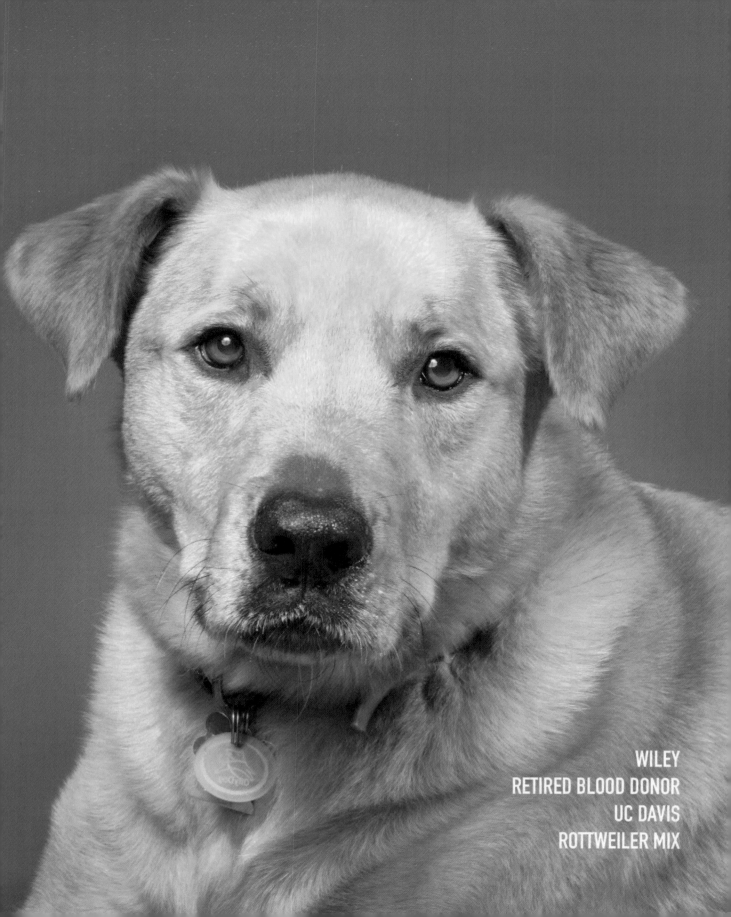

WILEY
RETIRED BLOOD DONOR
UC DAVIS
ROTTWEILER MIX

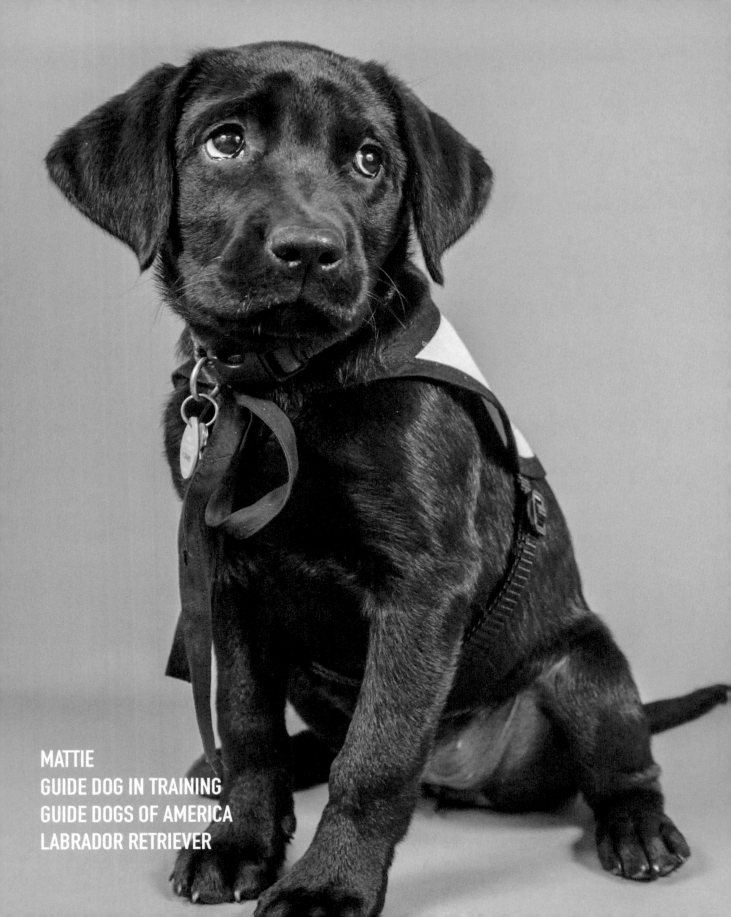

MATTIE
GUIDE DOG IN TRAINING
GUIDE DOGS OF AMERICA
LABRADOR RETRIEVER

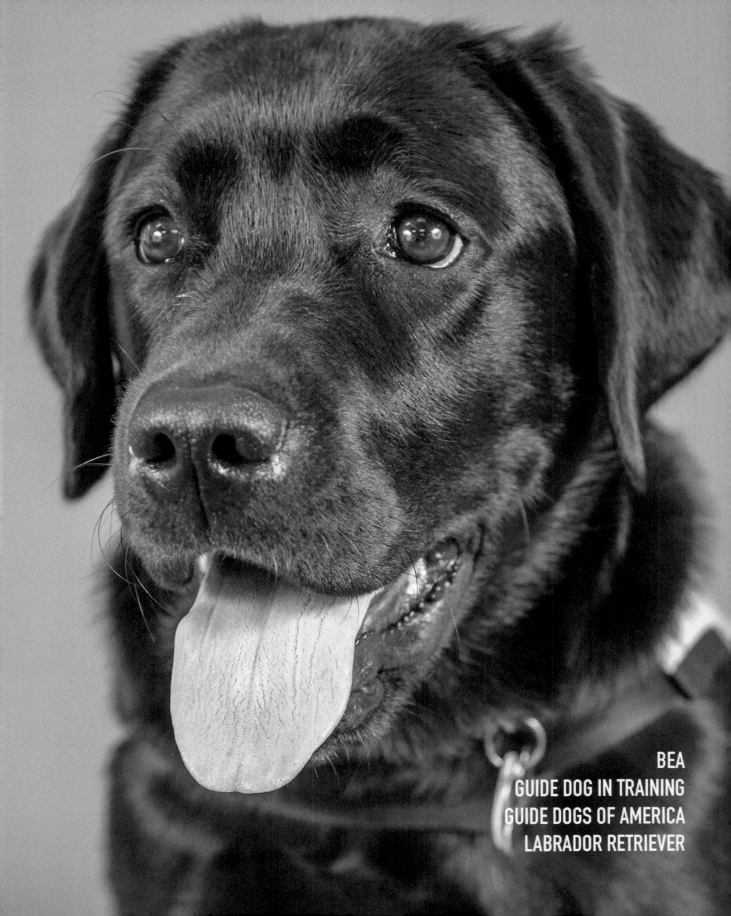

BEA
GUIDE DOG IN TRAINING
GUIDE DOGS OF AMERICA
LABRADOR RETRIEVER

As an Explosives Patrol Dog, MWD Barry F055 has done multiple missions to Dubai and Fallujah.

- Barry's Handler

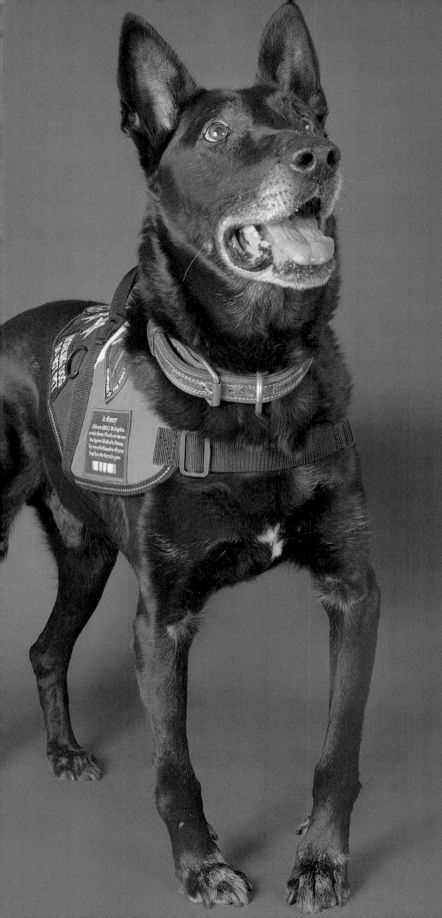

MWD BARRY F055
RETIRED EXPLOSIVES PATROL
BELGIAN MALINOIS

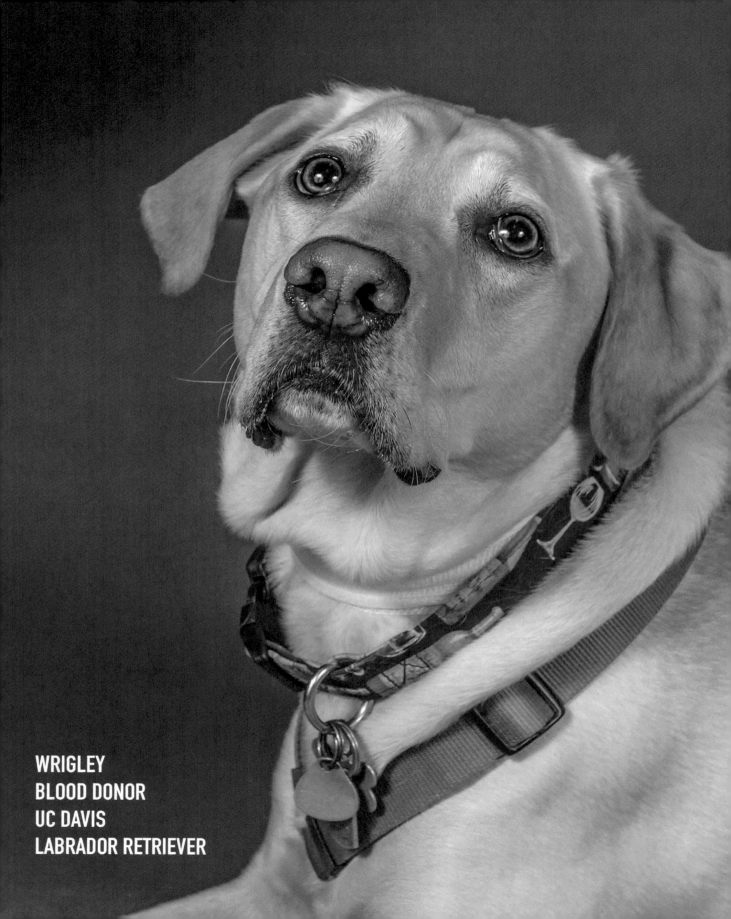

WRIGLEY
BLOOD DONOR
UC DAVIS
LABRADOR RETRIEVER

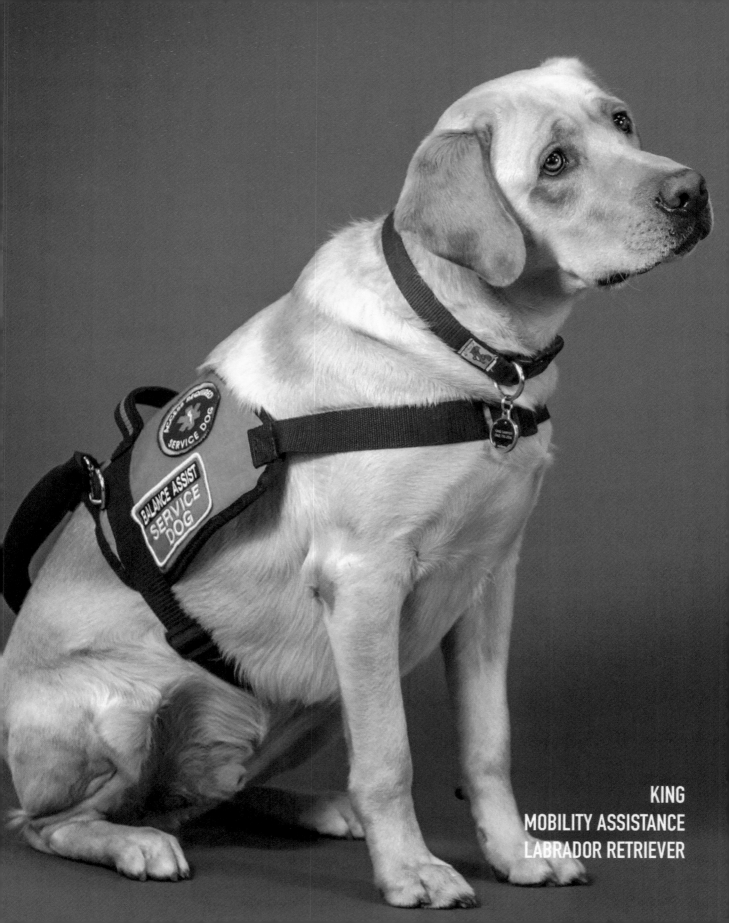

KING
MOBILITY ASSISTANCE
LABRADOR RETRIEVER

TRINITY
MEDICAL ALERT
UC DAVIS
AUSTRALIAN SHEPHERD

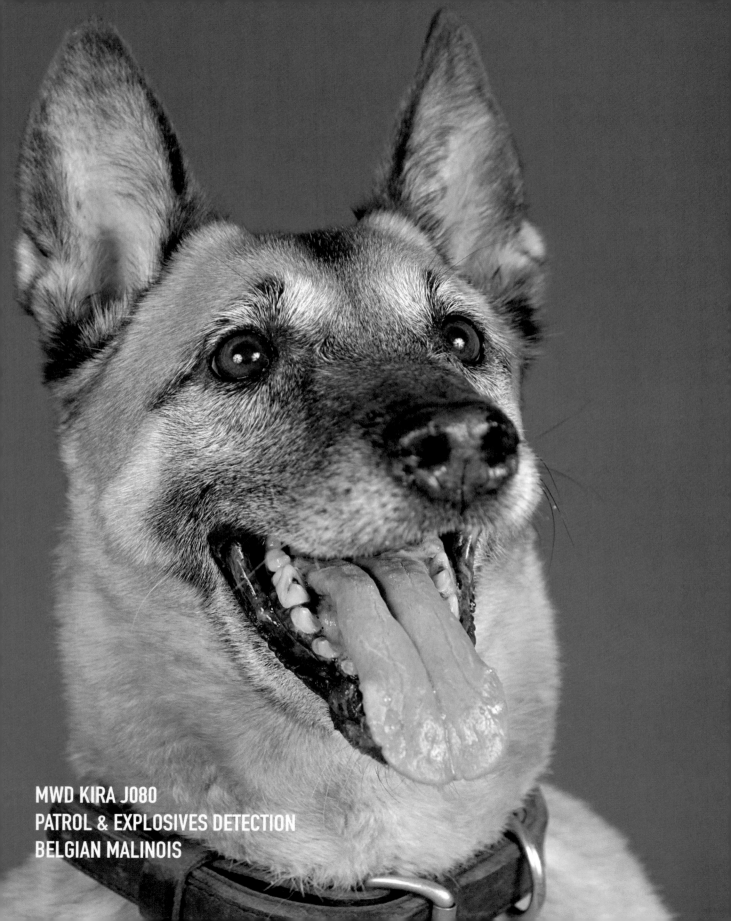

MWD KIRA J080
PATROL & EXPLOSIVES DETECTION
BELGIAN MALINOIS

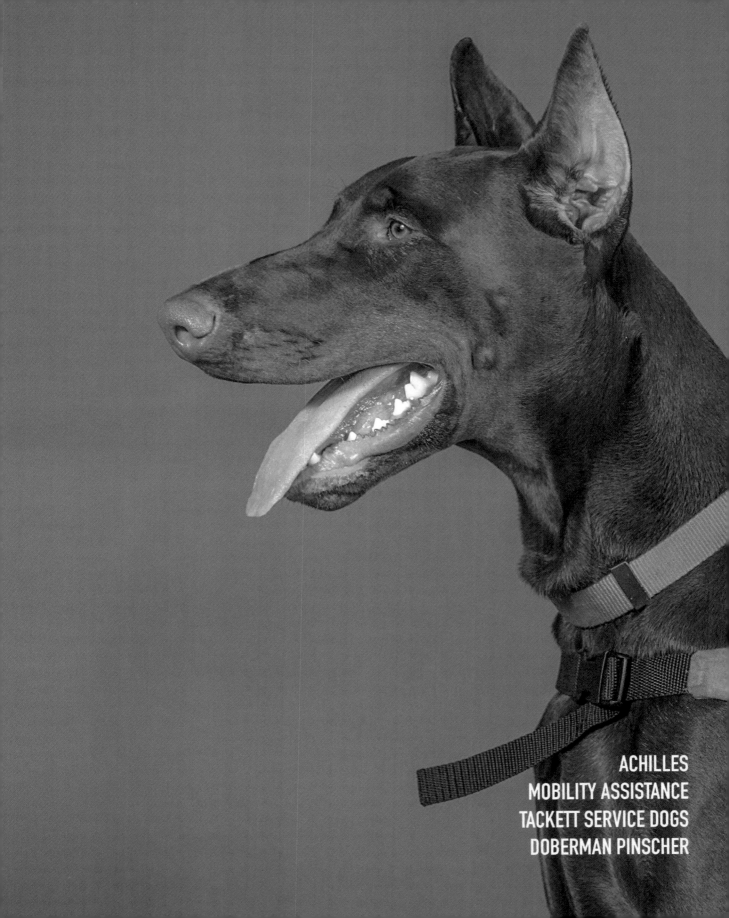

ACHILLES
MOBILITY ASSISTANCE
TACKETT SERVICE DOGS
DOBERMAN PINSCHER

Thea was in a severe auto accident - a spinout in a Jeep. She went through the windshield and was lost for several days. When Thea was found her owners took her to UC Davis Veterinary Hospital and said we do not want this dog due to her injuries. Soon after she entered the 4 Paws 4 Patriots Service Dog training program. She needs me as much as I need her. I have polio, post-polio syndrome, and am positive for the DYST gene for torsion dystonia.

- Thea's Handler

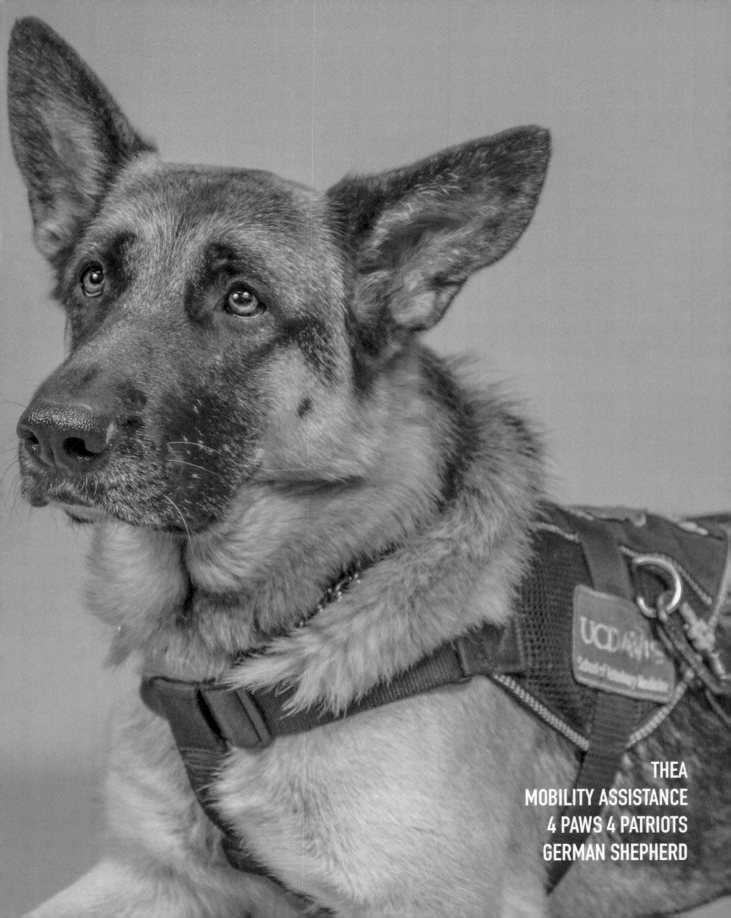

THEA
MOBILITY ASSISTANCE
4 PAWS 4 PATRIOTS
GERMAN SHEPHERD

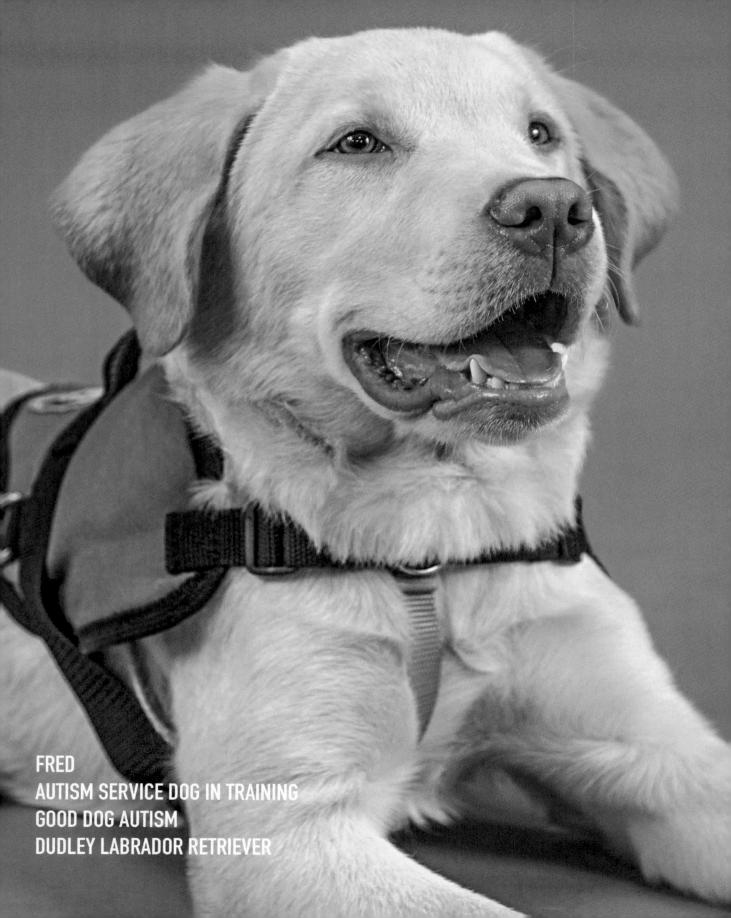

FRED
AUTISM SERVICE DOG IN TRAINING
GOOD DOG AUTISM
DUDLEY LABRADOR RETRIEVER

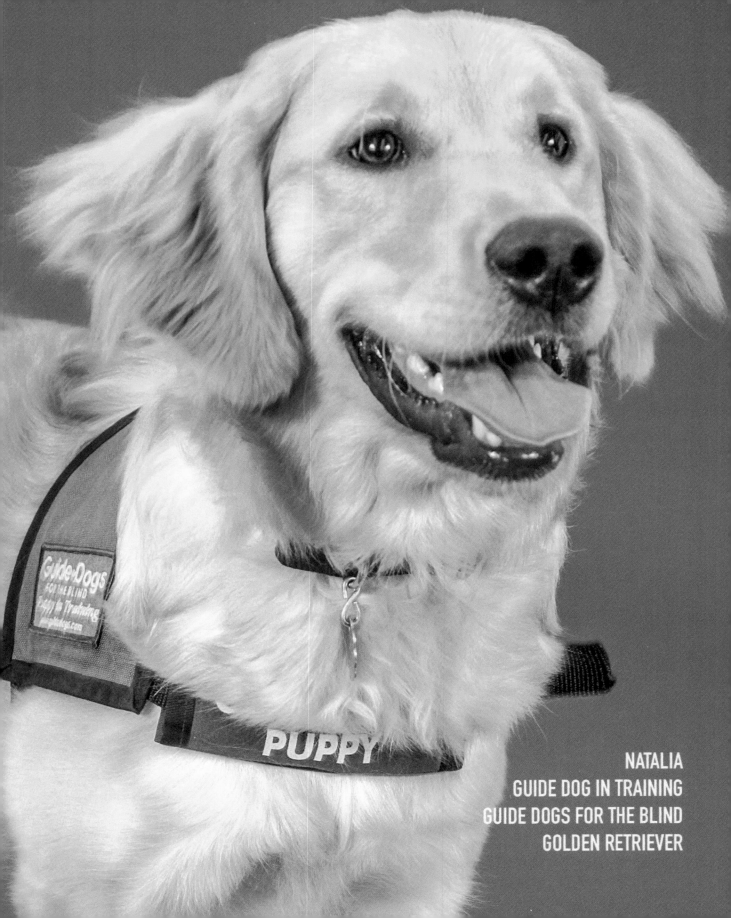

NATALIA
GUIDE DOG IN TRAINING
GUIDE DOGS FOR THE BLIND
GOLDEN RETRIEVER

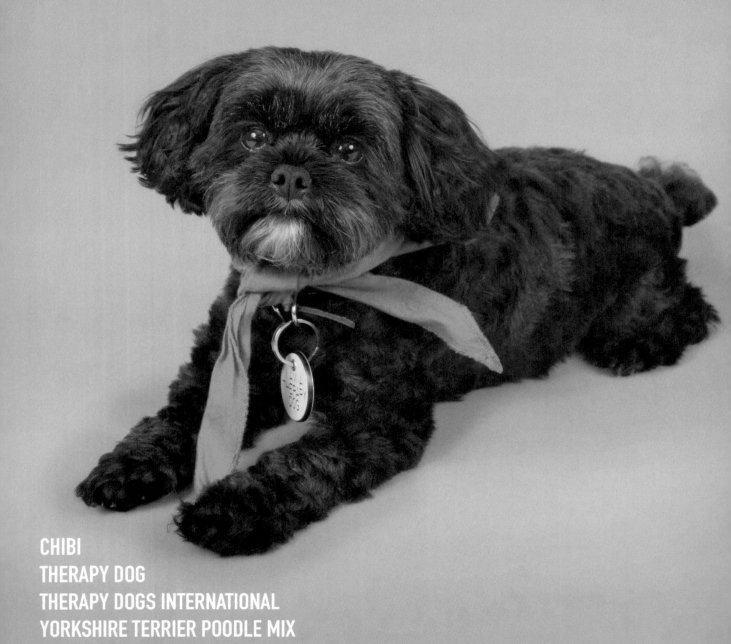

CHIBI
THERAPY DOG
THERAPY DOGS INTERNATIONAL
YORKSHIRE TERRIER POODLE MIX

SHAY
THERAPY DOG
DELTA SOCIETY
SCHNAUZER

RINA
MOBILITY ASSISTANCE & THERAPY DOG
CCI PUPPY TRAINED
GOLDEN RETRIEVER LABRADOR RETRIEVER MIX

Ricochet surfs tandem with kids and adults with special needs, disabilities and wounded warriors. She knows how to balance the surfboard with a passenger onboard. Her tireless charity work has raised over half a million dollars for human and animal causes.

- Richochet's Handler

RICOCHET
SURFICE DOG
PUPPY PRODIGIES
GOLDEN RETRIEVER

DRAGON
THERAPY DOG
COCKER SPANIEL MIX

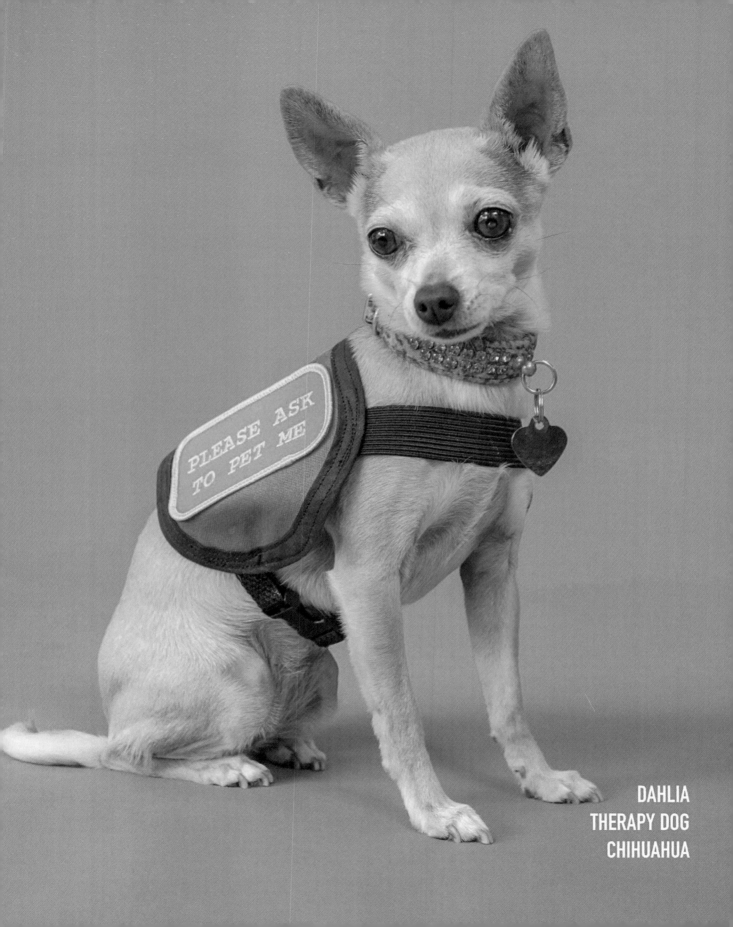

PLEASE ASK
TO PET ME

DAHLIA
THERAPY DOG
CHIHUAHUA

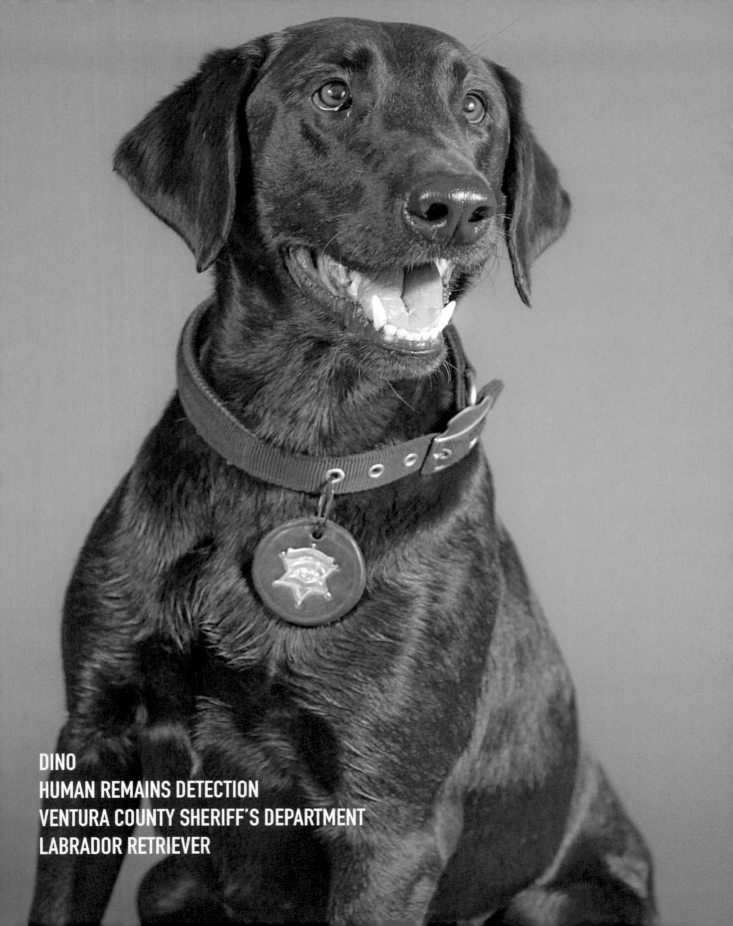

DINO
HUMAN REMAINS DETECTION
VENTURA COUNTY SHERIFF'S DEPARTMENT
LABRADOR RETRIEVER

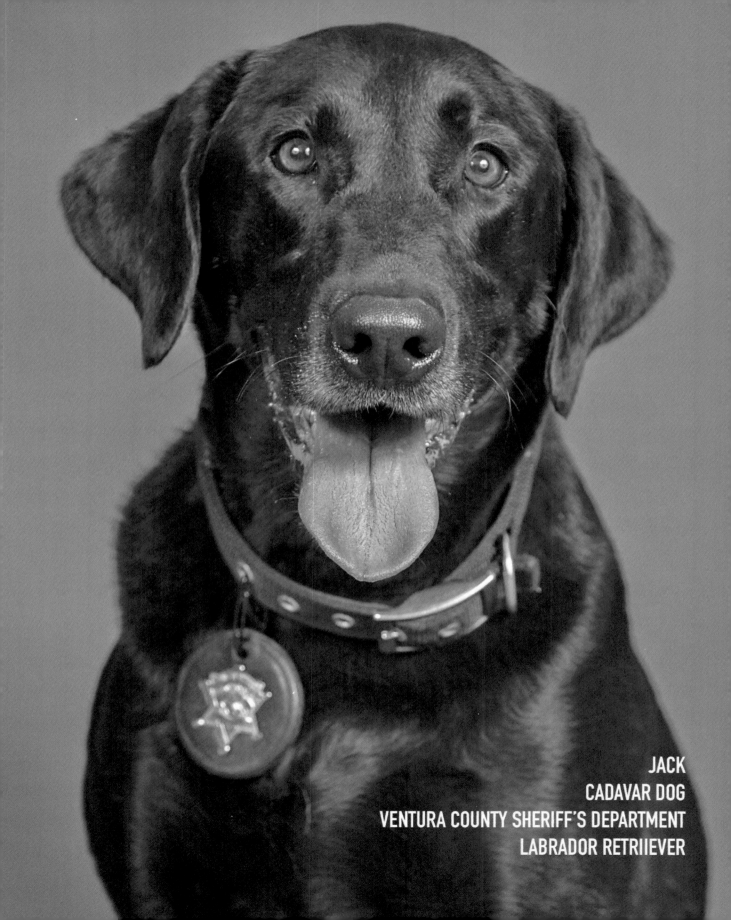

JACK
CADAVAR DOG
VENTURA COUNTY SHERIFF'S DEPARTMENT
LABRADOR RETRIIEVER

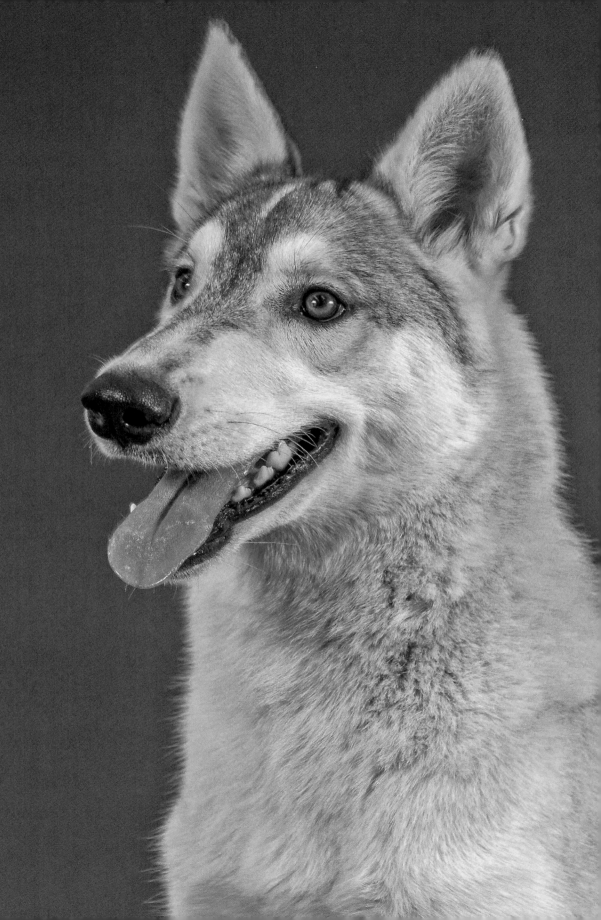

NAIMA
SLED DOG
TOMASKAN

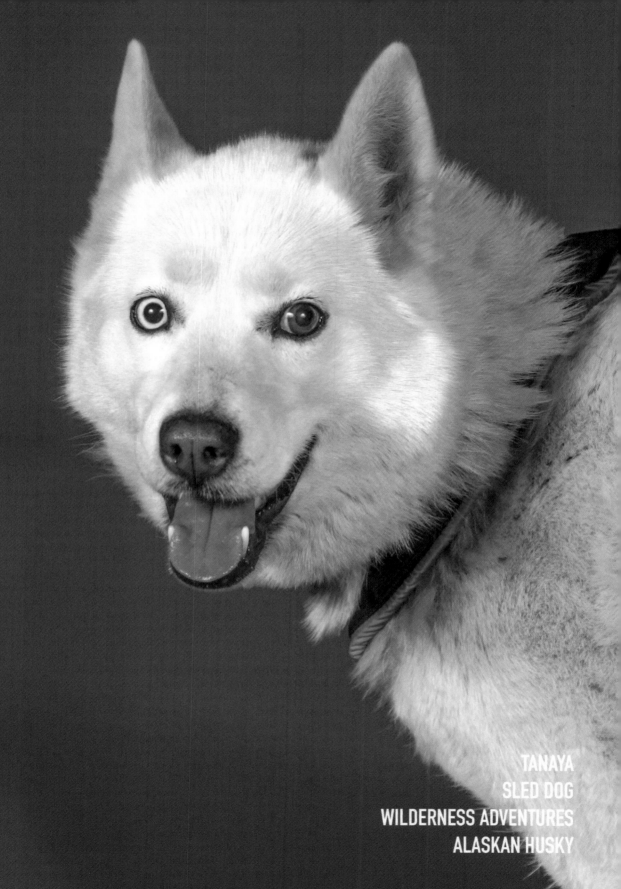

TANAYA
SLED DOG
WILDERNESS ADVENTURES
ALASKAN HUSKY

Sage has participated in a multitude of high profile missions and brought comfort to many worldwide. Sage has searched for survivors following Hurricanes Katrina and Rita and she went to Aruba to help search for the body of Natalee Holloway. She also was deployed to Iraq in 2007 to search for missing soldiers, where she was involved in many water, air and ground operations. To top all of this off Sage's very first mission was searching through the damaged Pentagon after 9-11 where she sniffed out the body of the terrorist who had flown American Airlines flight number 77 into the building.

- Sage's Handler

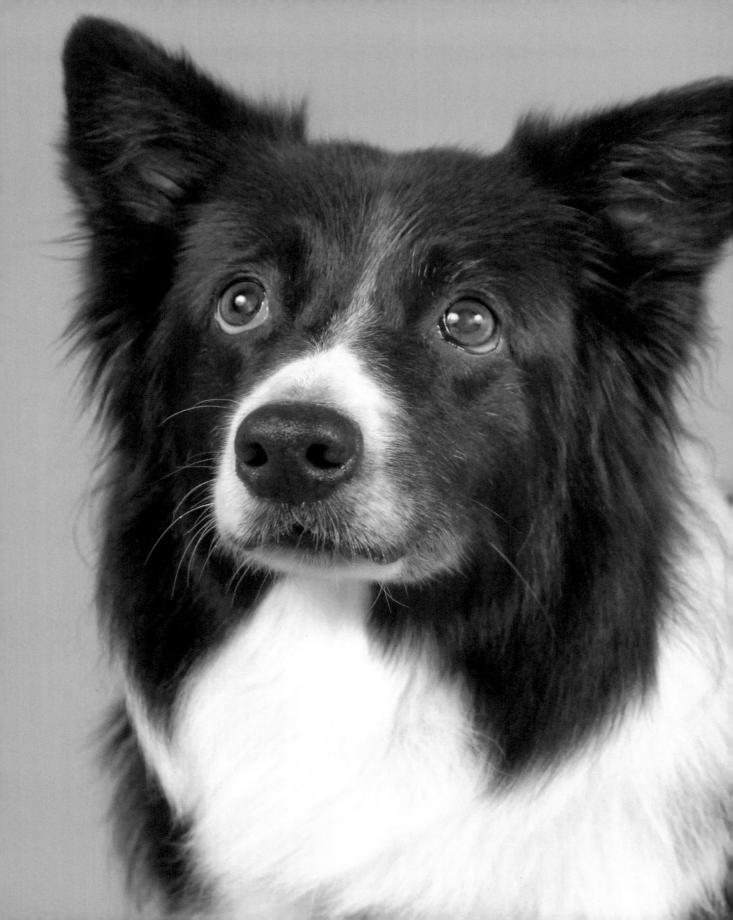

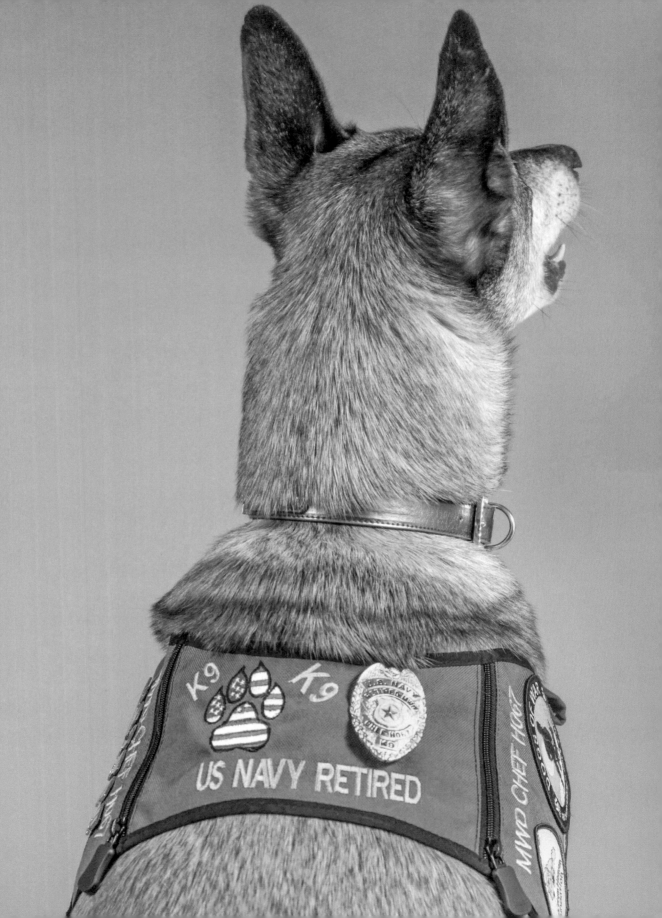

Working dogs do incredible things. In our book, you saw just a small sampling of the jobs dogs undertake in our world. There are many, many more careers for canines out there. Below are brief descriptions of the some of the tasks performed by the dogs of Working Like a Dog.

Accelerant Detection: Accelerant detection (also called arson detection) canines are trained to sniff out minute traces of accelerants like gasoline or lighter fluid that may have been used to start a fire. Each dog works and lives with their handler, usually a law enforcement officer or firefighter trained to investigate fire scenes.

Article Searching: A subspecialty of detection that involves locating specified articles, such as weapons, guns, or knives.

Allergen Detection: Allergen detection dogs monitor the environment for odors indicating known allergens to which their handler is severely allergic. Without a dog to give an early warning of the presence of these allergens, the handler could suffer a reaction and go into anaphylaxis, which is a life-threatening condition.

Autism Dog: An autism service dog assists an autistic person to help them gain independence and the ability to carry out activities of daily life. For the most part, these dogs are trained in tasks similar to those of service dogs for other sensory processing disorders. However, autism service dogs also learn skills specific to autism, like behavior disruption to distract and disrupt repetitive behaviors or 'meltdowns'; tethering to prevent and protect a child from wandering.

Avalanche Rescue: A subspecialty of Search and Rescue. An avalanche search dog detects human scent buried in snow, to depths of up to fifteen feet.

Blood Donor: Like humans, dogs have distinct blood types and also like humans, one of those types is a universal donor and therefore invaluable to providing blood for canine transfusions. Because canine blood has a shelf life of only 30 to 35 days, there's always a demand for blood donors. To become a donor, a dog must have no health or cardiac conditions, be on no medications and be free of infectious diseases. The dog must be calm and have the temperament to stay still while giving blood. Canine blood donors are often compensated for their life-saving work through free vet care, treats or belly rubs.

Cancer Detection: Dogs can be trained to use their sense of smell to detect and alert medical teams to the presence of various types of cancer in human patients. Two studies showed that dogs had over 90% accuracy in detecting lung cancer; dogs also have successfully detected melanoma, breast cancer and bladder cancer. In cancer detection, handlers work with teams of up to five dogs to see if all of the dogs show similar findings. Dogs are trained on cancer samples, healthy control samples, and disease control samples for 6-8 months before they are certified in cancer detection.

Cadaver: A subspecialty of Search and Rescue. A cadaver dog reacts only to the scent of human remains, either above ground or buried.

Disaster: A subspecialty of Search and Rescue. A disaster dog is trained to find human scent in disrupted environments, including collapsed buildings and areas affected by natural disasters like floods, earthquakes and tornados. These dogs are trained to work on unstable surfaces, in confined spaces and in other difficult urban situations.

Detection Dog: A detection dog - or sniffer dog - is a dog that uses its olfactory abilities to detect the presence of or traces of specific substances such as explosives, illegal drugs, wildlife scat, currency, blood, and even electronics such as mobile phones.

Drug Detection: A subspecialty of detection that focuses on finding drugs.

Guide Dog: A sensory assistance dog for a blind or visually impaired handler. A guide dog helps its handler negotiate the physical world, leading them around obstacles, stopping at curbs and steps, and waiting for traffic signals. Guide dogs learn to assess situations independently for safety. If a trained guide dog is given an unsafe cue from its handler, the dog will know to disobey it. The handler will understand that the dog is warning them of potential dangers. An example of this is a dog refusing to step into the street if there is oncoming traffic.

Hearing Dog: A hearing dog is similar to a guide dog but is trained to help a handler who is deaf or hearing impaired. The dog can alert the handler to a variety of sounds, such as doorbells, alarms, or telephones.

Medical Alert: Medical alert dogs can sense the onset of a specific medical crisis before it occurs and even before the dog's handler is aware that such a crisis is imminent. When the dog senses the impending event, he communicates it to the handler. These dogs can detect subtle changes in a person's odor, respiration and behavior that indicate the early stages of an event like an epileptic seizure, diabetes-related changes in blood sugar levels and crises related to psychiatric conditions.

Mobility Assistance: Mobility assistance dogs aid a person with limited movement capability, which may include wheelchair dependence. These dogs perform many tasks for their handlers: pushing the button for automatic doors, retrieving dropped items, turning on/off lights, opening and closing doors and fetching out-of-reach objects, such as a ringing phone.

Personal Protection: Personal protection dogs provide an extra layer of security for people and their families. Protection dogs are all trained in obedience but are also trained to defend their humans by a range of behaviors from barking at to attacking interlopers. Protection dogs aren't 'mean' or 'aggressive' dogs; they're dogs who take action when told to do so or when presented with a threat to their people.

Psychiatric Service Dog: A dog skilled in assisting a handler who has a psychiatric condition. Dogs learn to mitigate their handler's psychiatric disability by an array of techniques, like guiding the handler away from triggering situations, reminding the handler to take medication, and interrupting repetitive and/or injurious behaviors. Some of the conditions for which service dogs can be invaluable are post-traumatic stress disorder (PTSD), depression, anxiety and schizophrenia.

Post-Traumatic Stress Disorder (PTSD) Dogs: A subspecialty of psychiatric service dog. PTSD dogs work with individuals living with Post-Traumatic Stress Disorder (PTSD). These dogs improve their handlers' quality of life by alleviating their anxiety and distress. A PTSD dog will wake its handler from night terrors and nightmares, distract them from triggering stimuli, bring their medication to them on a regular schedule, and lead their handler to a safe place if they experience a panic or anxiety attack. They can also be trained to alert other people to assist in situations and, if necessary, activate an emergency alert system.

Search & Rescue: Search and Rescue (SAR) is a broad category of service dogs. Basically, SAR dogs use their canine superpower of scent to track and locate humans and human remains in various environments. Some dogs are trained to perform general tracking and locating; others are highly specialized, working only in certain environments -- like water or snow or urban -- or with either living or deceased humans. SAR dogs are tested and certified in a range of categories and skills, like tracking, trailing, air scent and cadaver.

Sled Dog: Sled dogs pull sleds across snow-covered terrain, either for sport (racing) or to transport supplies in cold, isolated environments.

Therapy Dog: A general category of dogs that join their owners in providing affection, comfort and emotional support for people in hospitals, retirement homes, nursing homes, schools, hospices, libraries and areas affected by disasters or tragedies. Although their work is invaluable, therapy dogs are not technically service dogs and therefore are not covered under the Americans with Disabilities Act.

Trailing: A subspecialty of Search and Rescue. This is often referred to as 'tracking' but is really a different task. A trailing dog attempts to locate a specific person by following the biological traces of the person -- usually minute particles of tissue or skin cells -- which are left behind as the person travels. These particles are heavier than air and will be found close to the ground, which is why a trailing dog works with its nose just about ground level. Bloodhounds are probably the best-known type of dog used for trailing. These dogs train by learning to follow a single scent only and not be distracted by other scents in the environment.

Tracking: A subspecialty of Search and Rescue. A tracking dog follows the specific path of a specific person. A trained tracking dog doesn't deviate from the path or cut corners; the idea is to trace the exact steps of the person who needs to be located. If no scent article from that person is available, the tracking dog will follow the path by environmental cues such as disturbed vegetation.

The following information is adapted from the US Department of Justice's published guidelines for service animals as covered by the Americans with Disabilities Act (ADA). The full text of this guide is available here: https://www.ada.gov/service_animals_2010.htm

What is a Service Dog?

Service animals are defined as dogs that are individually trained to do work or perform tasks for people with disabilities.

Under the Americans with Disabilities Act (ADA), state and local governments, businesses, and nonprofit organizations that serve the public must allow service animals to accompany people with disabilities in all areas of the facility where the public is normally allowed to go.

Per ADA regulations, service animals must be harnessed, leashed, or tethered, unless these devices interfere with the service animal's work or the individual's disability prevents using these devices. In that case, the individual must maintain control of the animal through voice, signal, or other effective controls.

How should I approach situations in which someone has a Service Dog?

• When it's not obvious what service an animal provides, only strictly-defined inquiries are required to be answered by the handler. Facility/venue staff may ask two questions: (1) is the dog a service animal required because of a disability, and (2) what work or task has the dog been trained to perform. Staff cannot ask about the person's disability, require medical documentation, require a special identification card or training documentation for the dog, or ask that the dog demonstrate its ability to perform the work or task.

• A person with a disability cannot be asked to remove his service animal from the premises unless: (1) the dog is out of control and the handler does not take effective action to control it or (2) the dog is not housebroken. When there is a legitimate reason to ask that a service animal be removed, staff must offer the person with the disability the opportunity to obtain goods or services without the animal's presence.

• Allergies and fear of dogs are not valid reasons for denying access or refusing service to people using service animals. When a person who is allergic to dog dander and a person who uses a service animal must spend time in the same room or facility, for example, in a school classroom or at a homeless shelter, they both should be accommodated by assigning them, if possible, to different locations within the room or different rooms in the facility.

• Establishments that sell or prepare food must allow service animals in public areas even if state or local health codes prohibit animals on the premises.

• People with disabilities who use service animals cannot be isolated from other patrons, treated less favorably than other patrons, or charged fees that are not charged to other patrons without animals. In addition, if a business requires a deposit or fee to be paid by patrons with pets, it must waive the charge for service animals.

• If a business such as a hotel normally charges guests for damage that they cause, a customer with a disability may also be charged for damage caused by himself or his service animal.

• Staff are not required to provide care or food for a service animal.

• The ADA does not require service animals to wear a vest, ID tag, or specific harness.

• Faking a service dog is a federal crime and in some states punishable by fines and/or jail time.

CPSIA information can be obtained at www.ICGtesting.com
Printed in the USA
BVIW12n0724220917
495225BV00007B/3